HAUNTED
MARTINSBURG

HAUNTED
MARTINSBURG

JUSTIN STEVENS

Haunted
America

Published by Haunted America

A Division of The History Press

Charleston, SC

www.historypress.net

Copyright © 2016 by Justin Stevens

All rights reserved

First published 2016

Manufactured in the United States

ISBN 978.1.46711.945.0

Library of Congress Control Number: 2016939299

To my grandmother Rayetta Brown, who told me my first ghost stories.
She was hilarious and a natural-born storyteller. Her memories bring a smile to
my face and sadness that she is no longer with us.

CONTENTS

ACKNOWLEDGEMENTS

Over the three years of this journey, many people have helped me behind the scenes. Compiling and researching folklore and ghost tales while establishing the Haunted History and Legends Tours of Martinsburg, West Virginia, was not an easy task. Along the way, many obstacles were met, challenges faced and frustrations experienced, but I forged on ahead only because of my sheer passion for Martinsburg's history and its ghost stories. Without the help and support of numerous people, I never could have accomplished my book.

I'd like to first of all thank my good friend and superb historian Keith Hammersla. His support, encouragement and help have been invaluable. His knowledge and research assistance have been tremendous assets, providing me with learning tools. I'd also like to thank Jonathan Mann and his wonderful family for opening the beautiful Boydville mansion and welcoming my tours into the house and onto the property. David Wilt shared his knowledge of local ghost stories and gave me a personal tour of the Shenandoah Hotel; he also graciously allowed tour groups inside of it. My dear friend and fellow tour host Dana Mitchell accompanied me on ghostly excursions and added to my enthusiasm for local folklore. Jennifer and Doug Fortune offered their expertise, special gifts and time in helping with the "haunted" fact-finding. I am indebted to my tour assistants, Rose Carter and Bev Stolipher, for the countless hours they have volunteered to assist me with the tours and for the stories they have contributed and helped to gather. LaRue Frye kindly invited me to her home and allowed me to interview her

for information. Mark Jordan and Laura Gassler supported me and helped me promote the tours in our community.

I would especially like to thank my loving parents, Wayne and Rebecca Stevens, for their unflagging support. My partner and my best friend, Marc Messner, has endured my crazy fascination with ghost stories, the paranormal and horror movies (despite his druthers) because he loves me and wants to help me succeed. My brother, Jason, was always ready with solid advice and literary expertise. Nicole Taggart helped with the tours, and she generously collected and researched stories. Michele Blanco, my most whimsical friend, believed in me and encouraged me to do something I love without fear of challenges. My cousin Sandy Kemner, with whom I have gladly reconnected, shared her experiences, stories and words of inspiration. Lisa Duff Craft, Ana Branescu and Donna Joy shared their special gifts. I'd also like to mention my precious little fur baby, Rhiannon, for her kisses, her love and her canine wit. I am very grateful to my editor, Karmen Cook, for her patience and assistance with this project and to The History Press for giving me the opportunity to write this book.

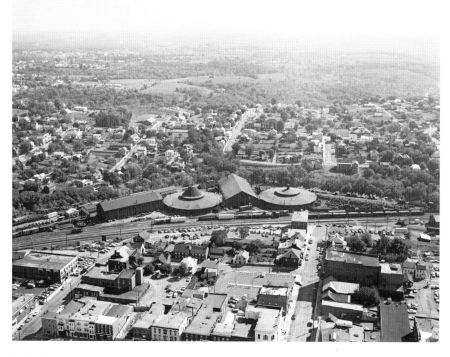

Aerial view of Martinsburg, West Virginia. *Library of Congress, Prints and Photographs Division.*

ACKNOWLEDGEMENTS

Lastly, thank you to all of the enthusiastic, wonderful people who have attended the tours. The positive feedback and sensational reactions keep me motivated. I'd also like to thank the many, many people who have shared stories and allowed me to interview them but who prefer to remain anonymous. Finally, I am grateful to our ancestors from Martinsburg's past. Without the hardships and sacrifices they made, there would be no history or stories to tell.

INTRODUCTION

Martinsburg, the county seat of Berkeley County, is located in the eastern panhandle of West Virginia. It is in proximity to historic tourist attractions such as Harper's Ferry and Antietam Battlefield in Sharpsburg, Maryland, and is the next town over from Shepherdstown. Though a small city, Martinsburg is steeped in history. Ravaged by the Civil War and devastated by fatal epidemics and tragedy, it went on to become a vibrant, thriving city. The beautiful Victorian and Colonial architecture that lines the streets today stands as a proud tribute to the town's heritage and the many hardships and challenges faced by its people. As a resident and native of this city, I never really appreciated just how many fascinating stories of the past it held. Only when I began developing the Haunted History and Legends Tours of Martinsburg, West Virginia, for the fall season of 2013 did I begin to realize the rich heritage of my hometown.

My interest in ghost stories has been a lifelong passion that I credit my grandmother with instilling in me. A good, honest, churchgoing Protestant she was; however, with her family roots firmly buried in Appalachian mountain folk culture, she also believed in tales of spooks and "haints." She was a natural storyteller and would effortlessly rivet and mesmerize me with stories spun at sunset and twilight. The impact of those stories, coupled with my own (some might say "morbid") devotion to classic horror films, horror icons and the macabre, ultimately led me to search out and compile my hometown's ghostly legends and lore. With so much history in the area, the town—not surprisingly—has many tales that range from intriguing and

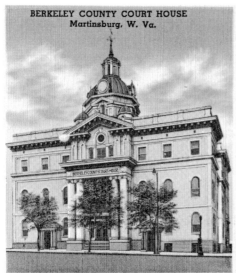

A vintage postcard of Martinsburg. *Boston Public Library, Tichnor Brothers collection #73284.*

amusing to downright bloodcurdling. People have reported witnessing and experiencing an astounding array of spirits and strange phenomenon.

What is it about ghost stories, the unexplained and "things that go bump in the night" that compel so many of us? Some people can be downright obsessive in their quest to prove the reality and the existence of the spirit world. Others have only a casual passing interest. And there are still others who are very skeptical and think the entire notion of ghosts and ghost stories is either "disrespectful" to their personal religious beliefs or scientifically not provable.

Whatever your stance, interest in the supernatural and the paranormal is undeniably high right now. There is an enormous selection of "reality" and documentary-style shows of varying quality and repute that air regularly on numerous channels. Ghost hunting, paranormal investigation and amateur attempts at "contacting" the other side are all the rage in our culture. Ghost tours are enormously popular, and most historic small towns and cities feature ghost walks of their historic districts. Books on the paranormal and radio shows, podcasts, Internet blogs and other tools of social media are further proof that there is a huge worldwide fascination with the topic.

It has been speculated that there has not been this much interest in the spirit world since the Spiritualist movement of the Victorian age. Escalated interest in this subject may be due to the eternal mystery surrounding it, since

the afterlife is an unresolved puzzle stimulating endless questions, theories and dead-ends. Perhaps with advances in science regarding the technical side of paranormal investigation, people are hopeful that the mystery will finally be resolved and the long sought-after answers will be obtained.

Let's look at the core of the "ghost story" and how the genre actually started through the framework of folklore and legend. You'll see that oftentimes these stories that have been orally passed down from one generation to the next reflect the fears and challenges being faced by people from a particular era of history or in a particular location. The struggles and the hardships faced by early settlers and the tragedy and horrors of the Civil War commonly provide historical foundations for stories. Ghost stories almost always have their roots at least partly in something that happened, and so to understand them, one has to look at the background of the particular region from which they derive. The stories that will be presented in this collection are based in historic events or about historic people who lived in Martinsburg.

I have tried to present these stories in a fashion that maintains the old-fashioned, oral tradition of ghost story telling. The purpose of this book is to present the folklore as handed down over the years and as inspired by history. I have also ventured beyond the legends and the stories themselves by presenting my own extensive research and the journey of trying to obtain the "truth" of the reputations behind some of these "hauntings." In addition to combing through dusty old files and barely legible historical documents to verify the history of the sites, I have also personally visited all of the locations and interviewed multiple witnesses of alleged "paranormal phenomena." I have also incorporated some paranormal investigators, as well as psychic mediums, and I will present those findings and outcomes as another viewpoint that permits a more well-rounded account of these stories' meanings. A psychic medium is someone who claims to have the ability to see beyond what is on the surface of the things we see on an everyday basis. He has the ability to pull back the veil, so to speak, and observe events and people of the past. She is able to communicate and relay messages from the deceased and the spirit world. These viewpoints will be presented so that readers, ultimately, can make up their own minds. Do the stories have natural explanations, or are they difficult to explain except as occult phenomena?

The folklore and ghost stories of a particular region are part of the fabric of a town's heritage and are just as important as the official history record. These stories give a town its special "character" and its essence. They can help generate new interest in "lost" or "forgotten" history or help create

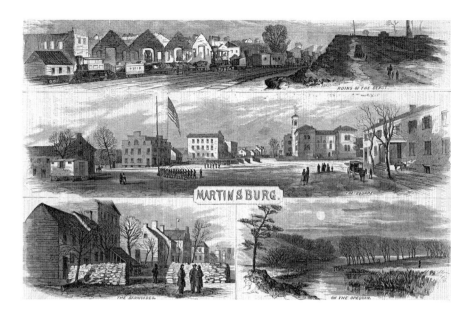

Views in and around Martinsburg. *Library of Congress, Morgan Collection of Civil War Drawings.*

interest in local regional history. It is my hope that I have imparted my interest in Martinsburg's history to readers of this book. In addition to being entertained and intrigued, you will hopefully learn more about this little town tucked away in the eastern panhandle of West Virginia and appreciate a unique and often overlooked aspect of its heritage.

Chapter 1

HISTORY OF COLONIAL MARTINSBURG

L ong before the area known as Berkeley County was ever settled, this entire portion of country was inhabited by various tribes of Indians. Long and bloody wars were carried on by contending tribes known as the Delaware and the Catawba. They were engaged in these wars when the valley first became known to Europeans and continued the fighting for years after the country was first inhabited by white settlers. Along the two great branches of the Potomac and Shenandoah Rivers, numerous signs and relics of their inhabitance were found years later. Early recorded history tells us that numerous human skeletons were unearthed; Indian burial mounds were said to have been scattered all over the entire county; and Indian pipes, tomahawks, axes, utensils, et cetera were constantly being unearthed.

At the site of Martinsburg, the Tuscarora Indians were the chief inhabitants, Tuscarora Creek being their place of residence and the source of the tribe's name. Along this creek, many Indian graves were located and, sadly, plowed down. After the eighteenth-century wars of 1711–13 (known as the Tuscarora War), over a period of ninety years, most of the Tuscarora left North Carolina and migrated north toward Pennsylvania and New York. They aligned with the Iroquois in New York because of their ancestral connection. They were sponsored by the Oneida and accepted as one of the Six Nations in 1722. According to NativeHeritageProject.com, during this ninety-year period of gradual migration, about 1,500 Tuscarora sought refuge in the colony of Virginia. Between 1719 and 1721, a group of Tuscarora established a main village on the rolling hills of Martinsburg.

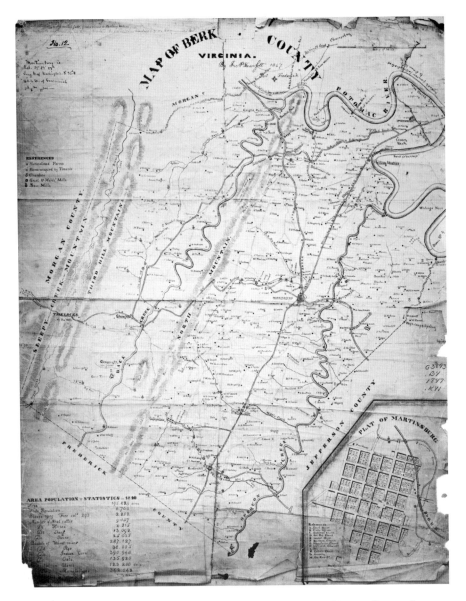

A map of Berkeley County, Virginia, from 1847, when West Virginia was still part of Virginia. *Library of Congress, Geography and Map Division.*

They were probably attracted to this area because of the natural freshwater springs located here. Unfortunately, very little is known about this period in time, and much of it appears to be lost or forgotten apart from a few anecdotal sources. One interesting bit of information is that part of the

Tuscarora Indian village was said to have been located at the present site of Martinsburg High School, as well as in other areas of the town. Throughout the course of this book, certain locations that are discussed have significant land connections to the Tuscarora Indians, and these will be pointed out to the reader.

Berkeley County was taken from Frederick County, Virginia, in the year 1772. Old Frederick, of which this section was originally a part, was laid off in 1738. The first sheriff was Adam Stephen, who was appointed and constituted from a commission from the governor of Berkeley County on April 18, 1772. A number of other justices were appointed at Edward Beeson's crude log house located on the north end of the city; consisting of one and half stories, it was where the first court was held.

Martinsburg was established in the month of October 1778 and was named after Colonel T.B. Martin, the last holder of the estate of this portion

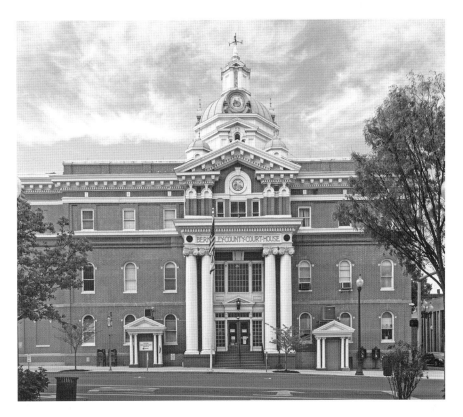

The Berkeley County Courthouse. *Library of Congress, Prints & Photographs Division, photograph by Carol M. Highsmith.*

of the country prior to its being laid off. According to an extract from the law at the time, our present city was established "whereas it hath been represented to this General Assembly that Adam Stephen, Esq. hath lately laid off one hundred and thirty acres of land in the county of Berkeley, where the Courthouse now stands, in lots and streets for a town, etc." Adam Stephen successfully advocated for Martinsburg to be the county seat of Berkeley County. On August 20, 1779, on the motion of Adam Stephen, sheriff, the plat of Martinsburg was ordered to be recorded with terms to purchasers as follows: "The purchasers of any lots in the above town, is to build on the lot a good dwelling house, to be at least twenty feet long and sixteen feet wide, with stone or brick chimney to same, in two years from the time of purchase, and, on failure, the lot to the return of the proprietor."

The Berkeley County Courthouse is now located in the town square, on the corner of King and Queen Streets. An immediately eye-catching structure, it was built in 1856 and remodeled in 1909. It was built on the site of a previous courthouse that was erected in 1779. Ironically, this spot is allegedly where the Tuscarora Indians held their Great Counsel fires centuries ago. Also located in the square was the original jail, which leads to the site of our first ghost story.

Chapter 2

GHOSTLY HITCHHIKERS AND NURSES AT KING'S DAUGHTER'S HOSPITAL

When Martinsburg was first established, the very first jail in the town, built in 1774, was located next to the Boarman Building, diagonally across from the courthouse in the town square. It was a small, two-story structure built of log and stone with the Market House attached to the rear. This early jail had only three cells, and as the town began to expand, it was decided that a bigger jail was needed. They were left with no choice, however, when on Christmas Day, someone drilled holes in the public whipping post and filled them with gunpowder, blowing the jail building to bits!

Since Martinsburg was very much a colonial village, the methods and means of punishment and torture utilized were characteristic of our English ancestors. At a public whipping post, people received lashings from a whip to their bare backs while their hands were restrained and tied to the pole. Stocks and a pillory were used as well. A seated person's ankles were locked into place in the stocks, which was a small wooden device with foot holes, while his/her legs were held straight out. Like the stocks, the pillory was wooden and had holes for a person's head and hands. It was a worse punishment than the stocks because the criminal had to stand while onlookers often threw rotten fruit and/or rocks at him. Public hangings also took place at the jail. The first "recorded" public execution in the town involved an African American man named Nace, who was a slave to General Horatio Gates. He was sentenced to death for breaking open the cellar of General Gates and "feloniously" taking a chest of money and clothes.

In 1795, the second Berkeley County jail was erected on the corner of Spring and King Streets, not more than a block down from the first. (An interesting historical tidbit: this site was said to have been the location of Chief Crane's large wigwam when the Tuscarora Indians were on this land.) This new jail was a tall, much larger, quite ominous-looking building, constructed entirely of limestone, and it also housed the jailor's family. Like the first jail in town, this one had a public whipping post, which was located on the side of the building, and a large enclosed jail yard in back, surrounded by a stone wall that was two feet thick and fourteen feet high. It was in this jail yard where many "neck stretchings" were said to have taken place. When a person was convicted of a misdemeanor, he was usually given the choice of confinement or being whipped; the prisoner often chose being whipped due to poor conditions within the jail.

During the Civil War, both Union and Confederate forces used the building, and they amused themselves by wagering to see how high a group could toss a prisoner and catch him in a blanket without dropping him. This jail was also the site where two victims of the only recorded lynchings

The King's Daughter's Hospital building, formerly the county jail for nearly one hundred years. *Photo by Justin Stevens.*

in Martinsburg were imprisoned. John Toliver and Joe Burns were both African American men being held in the jail to await trial and were seized by angry lynch mobs and hanged.

In the 1890s, Martinsburg was a railroad center, and accidents occurred frequently, injuring the railroad workers. These victims were generally carried on a stretcher to the old jail, but the care that could be given them under these circumstances was meager indeed. Oftentimes, nursing and care of the sick was done at home by the families unless it was a case of communicable disease, old age or lunacy, then the afflicted was taken to the Parish House, located on the northwest corner of Race and College Streets. In the early '90s, a mother traveling through gave birth to a baby and was put off the train at Martinsburg. Both were taken to the old jail building. Dr. James McSherry, the resident physician, called his sister, Miss M.G. McSherry, familiarly known as Pat, and said to her, "Pat, you have always wanted a hospital. Get your girls together, as I have sent you a patient to the jail." Miss McSherry called her friends, who were members of a Catholic group known as the King's Daughters, an organization founded for the purpose of doing charitable work of all kinds. The King's Daughters volunteered to care for the mother and baby until they were able to resume their journey. This group felt that Martinsburg needed a hospital. On June 8, 1893, it managed to purchase the jail building—which had been put up for sale due to overcrowding—for the sum of $2,610. A new jail was being constructed on South Raleigh Street. On May 15, 1896, the remodeled jail was formally opened as a hospital, "dedicated to the Glory of God and Offered to the Doctors for the Use of their Patients, Regardless of their Race, Creed or Politics."

On February 4, 1914, they received a state charter, granting authority to the hospital to open a training school for nurses. This school was opened in September of that year, and its first graduate was Miss Margaret Beard. Meanwhile, those who had to do with the hospital's progress and needs realized the remodeled jail was not adequate for the needs of an up-to-date hospital. The necessary funds needed for a new hospital could not be raised locally, and it was recommended that the only solution to the problem was to secure a community of Catholic Sisters who would be willing to take it over. Management of the old hospital was turned over to the Sisters of the Holy Ghost from Pittsburgh, who volunteered to take it over on February 1, 1951. The new hospital, directly across the street from the old one, opened to the public in March 1954. The old building served as housing for the nuns. Today, the new hospital serves as an assisted living facility for the elderly

and is known as King's Daughter's Court. The hospital was said to have shut down sometime in the 1970s; the old building was used as office space for a time but was later abandoned, falling into severe disrepair. All three floors deteriorated and were completely destroyed, leaving only the native limestone shell of the building. It has since been completely remodeled, and today it is being used as apartment housing.

With the history of this location, and all of the births and deaths that have occurred here, there are many ghostly tales associated with the old hospital building. One story says that during the Civil War, a woman who was nursing the sick and injured soldiers fell in love with her patient. He returned her affections, but with the war still in progress, they knew the relationship could not continue because the soldier would have to return to his army. Now, many legends have different variations, and sometimes details get changed vastly in their retellings. Another version of this story is much more scandalous. It states that the nurse was an African American woman who had fallen in love with her white male patient. He returned her affections and wanted to be with her as much as she wanted to be with him. They knew the relationship would never be accepted because they were each of a different race. The nurse, heartbroken, was riddled with conflicting emotions; she was a nun who had pledged her life to God and felt she had betrayed him for having these feelings for this man. However, she could not resist the deep emotional yearnings she felt for him. In both versions of the story, it is said that, in her despair, the woman walked up to a third-story window and threw herself out, plunging to her death on the pavement below. Some people say that when they are walking past the building, they hear the screams of a woman coming from one of the top windows; the screams travel down the building, and then they hear what sounds like the thud of a body hitting the concrete. Other people have claimed to have seen a woman in a red cape standing on the ledge of a top-story window and jumping off but never landing because she disappears.

The other story is more of an urban legend and has been told by many people over the years. It is probably one of the most well-known ghost stories of Martinsburg. Many years ago, a couple was vacationing in Martinsburg and was staying at a nearby hotel. They were driving down a nearby road at night and saw a little girl walking along the shoulder of the road. She appeared to be about twelve years old, with blond hair with a bow in it, and she was wearing an old-fashioned dress. She was the saddest and most lost-looking child you ever saw. The couple stopped the car and offered their assistance to the girl, and she told them she needed to get to the hospital to

be with her mother. She got into the backseat of the car and directed the couple to the old King's Daughter's Hospital building. When they pulled up in front of the building, there were lights on in the windows, and it appeared to be occupied. The girl was greeted by a nurse in an old-style nurse's uniform who came out of the front door and hurried her inside. The next day, the couple decided to go check on the little girl because they were concerned about her. They were shocked when they pulled up in front of the building to find that it was completely abandoned; some of the windows were smashed out, and it was in terrible disrepair. They began asking around town to try to get answers and to make sense out of what had happened the previous night. The response they got was that the hospital had been shut down for many years. Several other people are said to have had similar encounters with this mysterious little girl.

According to legend, the little girl's name is Jenny. Her mother was a nurse at this hospital in the early 1900s. Jenny was often left at home alone by herself while her mother worked long, late hours. One night, Jenny was sick or upset and desperately wanted to be with her mother. So she went out into the night to find her way to the hospital, but she never made it. She vanished and was never seen again; what happened to her was never known. In her grief, it is said that Jenny's mother died of a broken heart shortly thereafter. Some people claim that Jenny has been seen in other locations in town, such as on King Street, at the corner of Tennessee Avenue and at Green Hill Cemetery, where some say her mother is buried. This story is remarkably similar to the very famous, well-known urban legend of the "vanishing hitchhiker" that has been told all over the world in different versions and forms. Each version of the story usually involves someone picking up either a young woman or a young girl and being directed to take them to a location where they vanish upon exiting the car at the destination. This is a common story, and this appears to be Martinsburg's version of the tale. How the story started and the validity of it is debatable, but it's a fun story nonetheless and one in which some people firmly believe.

Current residents of the building have experienced some uncanny happenings. One resident said she was awakened every night by a light "tapping" or "knocking" sound on the door that separated her bedroom from her son's. She would get up and open the door, thinking it was her son, only to find he was curled up in his bed fast asleep. She began having her son sleep with her. On another occasion, she took a photograph, and upon seeing the photo, her children excitedly exclaimed, "Look at all the little faces!" Upon further inspection of the photo, she noticed several faces of

what appeared to be "other" children in the apartment. Another couple had the strange experience of their automatic dishwasher turning on unassisted. To turn on the dishwasher, there were three buttons that had to be pressed, yet somehow the wash cycle would mysteriously commence without being initiated by the tenants. The couple had a baby and a baby monitor, which they kept in the room with the infant at all times. When the man was alone in the apartment with the baby, he was audience to a deep, guttural voice uttering unintelligible words over the baby monitor. Upon checking on the infant, he found the child engaged in a peaceful, silent slumber. The couple made the decision to move out.

The newer hospital building is not entirely devoid of strange happenings, either. A nun wearing a white habit has been seen on one of the floors walking down the entire length of the hallway. An old, rickety elevator is believed by some to be haunted. One woman said that no matter what button she pushed, the elevator would always take her straight up to the roof. Others have claimed to hear the sound of the elevator running late at night, and upon inspection, they would find no one on board. Disembodied footsteps and the feeling of being followed, as well as lights extinguishing themselves, are also commonly reported. So whether merely urban legends or the products of overactive imaginations, these stories will likely continue to be told—and probably a few new ones will spring up as the living continue to come and go from these historic and haunted locations.

Chapter 3

HISTORY AND HAUNTINGS AT THE GENERAL ADAM STEPHEN HOUSE

Nestled just outside the downtown area of Martinsburg, past a bridge that spans the meandering Tuscarora Creek, is a peaceful, oasis-type setting. A beautifully manicured lawn and grounds entice the eyes and direct one's sight to the focal point of this tranquil environment. Perched majestically atop a hill sits a fine example of stone Colonial architecture. It is the home of the founder of Martinsburg, General Adam Stephen. Walking back to this beautiful property is like stepping back in time, and the surroundings seem to echo and reverberate the rich history that encompasses it.

Adam Stephen was born in Scotland around the year 1718. He obtained his degree as a surgeon at the Universities of Aberdeen and Edinburgh in 1746. He came to America in 1748 and established his own doctor's practice in Fredericksburg, Virginia. He purchased land in Frederick County, Virginia, in 1750 that became the "Bower" property in present-day Jefferson County, West Virginia. In 1754, information reached the colonial authorities in Williamsburg that the French and Indians had taken possession of the northwestern part of Virginia, on the Monongahela, murdering and driving away the settlers of that section. The General Assembly authorized the raising of six companies for the recovery of that territory. George Washington became lieutenant colonel; Stephen was appointed major but was later appointed lieutenant colonel (and Washington, colonel) when the regiment was reorganized on August 14 of that same year.

At the commencement of the Revolutionary War in December 1775, Stephen was commissioned as Virginia colonel of one of the regiments

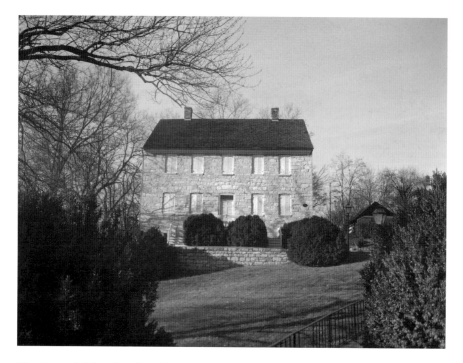

The General Adam Stephen House, home of the founder of Martinsburg. *Photo by Justin Stevens.*

raised by the state. On September 4, 1776, he was appointed by Congress as a brigadier general of the Continental troops, and on February 9, 1777, he was promoted to the rank of major general. He again worked alongside George Washington in the Battles of Trenton and Princeton, and in 1777, at the Battle of Brandywine, was in command of a division as major general.

After General Stephen had returned to this area in 1768, and before his military service had resumed in the Revolutionary War, he created the county of Berkeley through an act of the General Assembly. Martinsburg was made the center of the new county, and General Stephen was appointed first high sheriff on May 19, 1772. When General Stephen was withdrawn from the county for his services in the Revolutionary War, establishment of the town was placed on hold until his return in 1777. In 1778, Martinsburg was established by an act of the General Assembly and laid out on 130 acres of land, granted for that purpose by General Stephen. Stephen also operated two nearby mills, a distillery and an armory.

In 1788, General Stephen was elected by voters of Berkeley County to the convention in Richmond on June 2 to determine whether Virginia

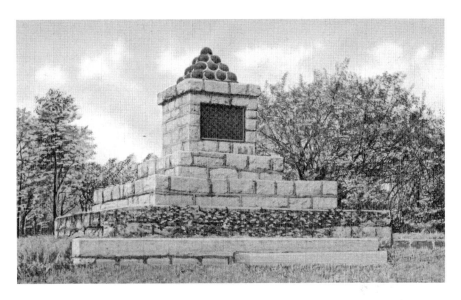

Monument to Major General Adam Stephen, located in the 600 block of South Queen Street. *Boston Public Library Tichnor Brothers collection #73283.*

would give its consent to the adoption of our present federal Constitution. General Stephen gave a stirring speech in favor of the adoption of the Constitution, which influenced the Virginia delegates to ratify the United States Constitution and, in turn, led other states to ratify it at their state conventions. This is considered General Stephen's greatest contribution to the future of America. General Stephen died in Martinsburg on July 16, 1791, and is buried on his brother Robert Stephen's estate on the "monument lot" in the 600 block of South Queen Street.

The land on which the present house is situated is believed to have been the site of a smaller log home built by General Stephen around 1770. It's thought that the beautiful stone house was built in the late 1770s or early 1780s. In back of the house, there are two utility buildings, a washhouse (constructed of logs) and a smokehouse (constructed of limestone). The house was given to the city in 1959 by William Evers, a former town resident then living in California, and the General Adam Stephen Memorial Association was formed with the purpose to restore it as a memorial to the town founder and to acquire furnishings suitable for the period of its early inhabitation. As stunningly beautifully and tranquil as the grounds and property are in the daylight hours, when darkness falls and shadows are cast from the large trees flanking the area, it all seems to take on a quietly eerie atmosphere. What is by day a large,

breathtakingly gorgeous home by night becomes ominously silhouetted against the sky.

Ghostly activity was experienced as far back as one hundred years ago, when the Phillip Showers family lived in the house. In an article that ran in a local 1960s publication regarding the family, it stated that during the horse-and-buggy days in the early 1900s, some of the grandchildren used to spend some nights in the house during the week while they attended school. Every night, while studying their lessons in the dining room, they would hear footsteps coming down the stairway, walking to the end of the hall where they were studying and coming to a sudden stop. Upon opening the door, no one was there. These footsteps have been heard by many docents and volunteers working in the house over the years, and they usually are in this same area, which seems to be where a lot of odd and unusual things have been reported.

In this same room, in the mid-1990s, a séance was held. During the attempt at otherworldly contact, one participant reported afterward that she had heard voices speaking in the house, but she couldn't discern what they were saying. A couple of the participants became weak and disoriented and had to leave before the séance was completed. So it was the general consensus among everyone in attendance that contact with the other side was made.

About six years ago, while closing up the house after a nighttime event, two members of the Adam Stephen Association were in the front hallway and saw an older gentlemen coming down the stairwell. As he proceeded down the hallway closer to them, they realized he was missing the bottom half of his legs. He was visible only from the knees up and was floating rather than walking. The phantom figure passed through the front door onto the front porch. This however, was not the first sighting of this ghostly figure; they learned of a much earlier encounter. A couple of years ago, a man who was the son of a previous caretaker of the property recalled that on one Sunday afternoon in the 1970s, when he was a child, only he and the tour guide were sitting in the hallway waiting for visitors to arrive. As they were sitting there, they saw the apparition of an older man coming down the stairs, walking up the hallway and exiting the front door. Perhaps this is the spirit responsible for the disembodied footsteps heard by so many over the years. This is an example of what is known as an "imprint haunting" in paranormal theory. An imprint haunting is believed to be an energy imprint on an environment from past events that keeps replaying itself over and over like a broken record. It's believed that this could possibly be the ghost of

General Adam Stephen; however, there are no photographs or sketches of him in existence, so no one knows exactly what he looked like.

Only a couple of years ago, a paranormal investigative group came into the house to explore the claims of supernatural experiences in the home. They picked up some electrical impulses with their devices and caught some strange streaks of light in the hallway just below the railing of the stairs. As they were standing with the curator in the hallway, about to exit the front door, everyone heard the faint humming of a song from someone who was not visibly present with them.

Painting and electrical contractors working in what is known as the "Surgery Room" have reported hearing footsteps but have also had some more tangible hair-raising experiences. One day, as a caretaker was doing yard work on the back lawn of the house and a worker was alone in the home, something very strange happened. The back door came flying open (from the back door to the ground, there is about a six-foot drop; a ladder has to be dropped down because the back porch is no longer there). Suddenly, the worker made a flying leap out of the door to the ground without even bothering to drop the ladder and came running up to the caretaker, scared out of his mind. He nervously said that while he was in the house, an unseen presence grabbed him, and he was so terrified that he refused to go back into the house to retrieve his tools or complete his work.

Former residents of the house who have visited to see the restored home have stated that when they lived there in the 1950s, rocking chairs in the upstairs bedrooms would frequently rock without any human intervention or anyone near them. In the 1970s, a tour guide standing in the doorway of one of the bedrooms and looking into the hallway reported seeing the ghost of a young girl coming down from the attic stairs and disappearing in the hallway. Docents alone in the house have also reported the sounds of what seems to be heavy furniture being dragged across the floor of the upstairs when they have been alone in the house downstairs.

The most recently reported incident occurred when a docent was alone in the house, closing it up for the day after visiting hours had ended. As he was going around closing all the shutters, he heard what appeared to be someone trying to force his way through the closed and locked front door. He walked into the hallway and watched as the doorknob spun right before his eyes. He lifted up the board that secures the door to keep the house safe from intrusion and opened it. Upon bravely opening the door to confront this aggressive person intent on gaining entry, he was shocked to see that no one was there, and there was no sign of anyone near the house—at least, no one living.

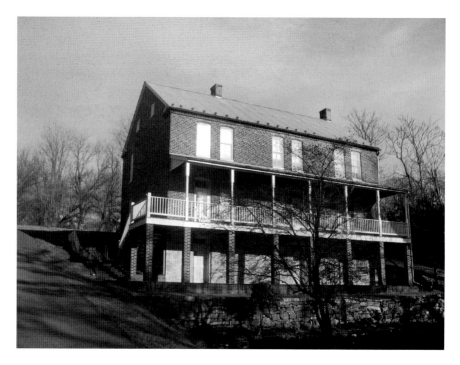

The Triple Brick Museum, located next to the Adam Stephen House. *Photo by Justin Stevens.*

Located on the property, right across from the General Adam Stephen House, is a large building known as the Triple Brick Museum. This structure was built by Phillip Showers in 1874 and was divided into apartments as housing for railroad workers. In early records, it was listed as "Tribble (Triple) House" or "the brick house divided into three dwellings." The current caretaker and curator of the house lives in one of these apartments. The building now contains a museum of artifacts and memorabilia of life in old Martinsburg. Items on permanent exhibit include early surveying equipment, flax and wool spinning wheels, quilts, railroad memorabilia and various items related to the industrial, social and cultural history of the town from the 1800s to the early 1900s. There also fossils, primitive stone tools and arrowheads, as well as collections of military uniforms from various American wars. Fascinatingly, there are even glassware, shards of pottery and late eighteenth-century glassware on display that have been uncovered during archaeological excavations on the Adam Stephen property.

The curator says that on some evenings when he has been sitting on the porch of this building at just about dusk, as it's beginning to get dark, he has seen shadowy figures darting about the front lawn that surrounds the

General Adam Stephen House. Another witness to this strange phenomenon once followed these figures around the property. In the Triple Brick building, the scent of a woman's perfume will sometimes fill areas, tantalizing the senses. On one occasion, in his apartment, the curator and another person had a camcorder and were filming a couple of cats he had as pets. When they played back the footage, there were two spheres of light—or "orbs," as they are commonly referred to in the paranormal community. They were zigzagging and shooting around the room in varying directions. Dust particles would not move in such jerky, irregular directions, so he believes an unexplained anomaly was captured on film. A former resident of the apartment used to report hearing footsteps coming up the staircase to the bedroom and seeing the figure of an elderly man standing in the doorway staring at him as he was lying in the bed. An elderly woman would also appear in a corner of the bedroom in the darkness and would stare at the bedroom's now quite shaken inhabitant.

So who or what haunts this property and is making itself known in such dramatic ways? There are a couple possibilities that may shed some light on some of the disturbances. Underneath the main house, there is an opening to a series of natural underground tunnels that run underneath the eastern edge of Martinsburg. What these tunnels are and why and when they were formed is one of Martinsburg's big unsolved mysteries. Many think they were used as an escape route from possible Indian raids or an attack from the British or other foe. Others think they were used by slaves as part of the Underground Railroad.

Some notes in the possession of the Adam Stephen Association written by Fred Voegele, a renowned local historian from the 1930 to 1950 period, reveal something startling and intriguing. A homeowner doing work in the house in 1936 found the remains of two human skeletons in the cave beneath the kitchen floor of the main house. What were the origins of the skeletons? Why were they underneath the kitchen floor, hidden in the cavern below? It's a mystery that has never been solved. The house was also used as a field hospital for wounded soldiers during the Civil War. Perhaps some of the soldiers who perished on the property are still present in spirit, reaching out to the living for a little comfort. Right above the house, the railroad passes by, and there have been several violent deaths and accidents on that section of track; perhaps the spirits of those poor, unfortunate souls are attached to the area and wander aimlessly, unaware that they've passed on.

The house and the land on which it is situated on probably holds many secrets and mysteries that we'll never know the answers to. But

one thing is for sure: for the people who have experienced these strange happenings, there is no question that there is something going on beyond our realm of understanding!

Chapter 4

TOLIVER AND THE HELLHOUNDS OF EAST BURKE STREET

If we look into the annals of Martinsburg's dark history, there is one event that stands out as among the most disturbing. In 1875, the entire town was shocked to its core by a horrible crime. A young white girl of about twelve years old was found brutally raped and murdered. Her name was Annie Butler, and the person accused of the unspeakable act was an African American man named John Toliver.

Public indignation against Toliver ran high as the case went to trial in the Berkeley County Court. His counsel, Judge Blackburn of the city and Marshall Ward Lamon of the District of Columbia (a friend of Abraham Lincoln from the time they were both lawyers on the circuit court and Lincoln's personal bodyguard during his time as president), made an earnest effort to acquit him. While proceedings for the case to be removed to federal courts were pending, Toliver was held in the county jail. The townspeople were outraged, for they wanted immediate justice for the horrific crime of which they believed Toliver was guilty. At midnight, a mob of no fewer than four hundred masked men, armed with sabers and pistols, surrounded the jail. They entered, overpowered the jailor and took his keys and seized Toliver, taking him into their custody. The mob took the accused to a vacant lot about a mile north of town, at the intersection of the Hedgesville Road and Williamsport Turnpike, and stopped at a large locust tree with strong, sturdy branches. They stood him up in the back of the wagon and placed a noose around his neck, then pulled the wagon out from under him. The terrified, persecuted

Toliver was dangling lifelessly within a matter of seconds as his neck snapped in the drop.

After the lynching, the mob attendees placed Toliver's lifeless body in a wooden box and took him to the old abandoned African American cemetery next to Green Hill Cemetery on East Burke Street. They placed the coffin in the road opposite the cemetery with the idea that the African American community would bury him. None of them did, and the box just continued to sit there. A couple of women who lived nearby took a hatchet and pried off the lid to see what the corpse looked like. After they had satisfied their morbid curiosity, they went on their way. Later on that night, some white men came along and decided they would dispose of the body. They buried the remains in a rain-swept gulley just outside the east fence of the cemetery. Years later, the spot came to be used as a neighborhood dumping ground, and Toliver's body, no doubt, has been covered over by many feet of accumulated rubbish.

Guilty or not, Toliver came to be known as the "Boogeyman" of Martinsburg. For years, it was the story parents would tell their children to frighten them into staying home at night to keep them out of mischief. If they misbehaved, the vengeful spirit of Toliver would snatch them up in the night. In 1939, a local newspaper column titled "Know Your Martinsburg," written by Fred Voegele, presented a bizarre story. In this article, it stated that on certain dark nights of the year, three black dogs the size of calves were seen walking down the East Burke Street hill. When they would get to the site of the railroad underpass, they would vanish. An Irishman who lived on High Street was walking home late one night and encountered these three fearsome hounds in the middle of the road. They were so frightening and vicious looking that he made the sign of the cross and then ran as fast as he could up the hill to his house, where he jumped in bed and threw the cover over his head faster than you could say, "Tic tock." These phantom hounds were mentioned again in an article in 1947 and then again in 1955. In the 1955 article, it stated that two proper ladies living in the town were confronted by these nightmare-inducing creatures on the same dreaded road. Well, the good people of Martinsburg apparently did not know what to make of these frightening happenings, and one of the newspaper articles speculated that perhaps at least one of the devil dogs might be the spirit of Toliver, the assumption being that he was condemned to walk the earth in the form of a hellish hound for the awful crime he had committed in life. Now, there is no doubt in my mind that Toliver had nothing to do with the sightings of these "ghost dogs." I think there was something else going on here.

West Virginia has always had a reputation for stories and legends of monsters and mythological creatures, but Martinsburg has the distinction of having its own such tale. Hellhounds are said to be supernatural beasts common in Irish and Celtic folklore, as well as English lore. Most tales describe them much in the same fashion as these articles: the size of calves, jet black in color and usually with fiery red or yellow glowing eyes. Some theories state that they are akin to the Irish banshee, the white-shrouded wraith whose wails are a harbinger of death, and that seeing the hounds is an omen that someone in your family is going to die. Another speculative idea is that they are supernatural guardians of the underworld and of cemeteries and graveyards. Most stories place them in or near these types of settings. Others believe they are the spirits of criminals damned for eternity to wander the earth as the devil's minions in the form of these demonic creatures.

Interestingly enough, there is a lot of folklore attached to "crossroads"—places where roads intersect and form a "cross." They are believed to be magical, mystical places. Ancient tales tell how evil forces and even the devil himself was believed to manifest at crossroads and that those who practice the dark arts would go to these places to tap into the dark energy to cast evil spells and hexes on their enemies. It has also been said that gallows would sometimes be placed in the middle of intersecting roads and the executed criminals buried at that spot to deter and confuse their spirits from returning to haunt their persecutors.

The hellhounds reported in Martinsburg are said to vanish at the underpass, the old railroad crossing, where a crossroads is formed. This section of East Burke Street ascends a hill leading into an area of town known as "Irish Hill." It is so named because it was where Irish railroad workers were housed. Perhaps it's no coincidence that the first documented sighting involved an Irishman who lived in this particular area, as so many legends of the hounds are rooted in Irish lore. This road eventually ends at Green Hill Cemetery, another strange place where some people have claimed to have seen the hounds. So the environment and the setting seem to fit the lore of the hellhounds as told in various parts of the world. The only documented sightings of them in the eastern panhandle, to my knowledge, have been here in Martinsburg. So if you should be walking alone late at night up the East Burke Street hill and see three abnormally sized dogs, blacker than the night, you just might be the next person to encounter the hellhounds of Martinsburg!

Chapter 5

A SUPERNATURAL MYSTERY AT THE MARTINSBURG PUBLIC LIBRARY

Situated in the center of town in the square, right across the street from the historic Berkeley County Courthouse, is the Martinsburg Public Library. This public institution has long been an important part of the local community and has been an invaluable resource for my research for the ghost tours and the writing of this book. I've spent many afternoons in the history archives room, scouring through history books and scrolling through old historic newspapers on microfilm. The library's very own ghost story was one of the first I learned of when I began collecting haunted stories for the ghost tours. It also happens to be one of the most unique and bizarre of all the stories I've gathered on the historic district. One would not think, with it being a "newer" building, that there would be startling reports of supernatural occurrences from some very credible witnesses. But it goes without saying that among knowledgeable enthusiasts of the paranormal, sometimes it isn't the building itself but the land on which it is situated and its previous structures and occupants that can be the source of disturbances.

The history of this site goes all the way back to 1815, when a large building, originally known as the Flick Building, was constructed. It then became known as the Wiltshire Building and was the site of the city's first library when a group of local gentlemen met and formed the Martinsburg Library Society in May 1825. During the Civil War, it served as headquarters for General Seward, the military governor of Martinsburg. It also became known as the house where a drunken Union officer rode his horse into

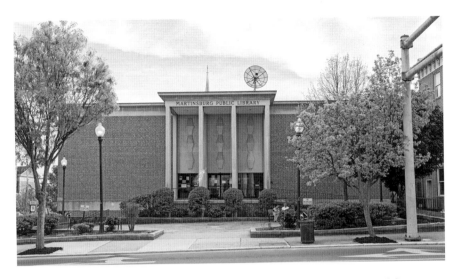

The Martinsburg Public Library, site of the former Wiltshire Building. *Library of Congress, Prints & Photographs Division, photograph by Carol M. Highsmith.*

the hall, up the spiral staircase and across the polished floors in search of Confederate spies. The horse's cleat marks were said to have been forever imprinted in the woodwork of the first few steps of the staircase.

The truth of this incident involved a messenger carrying the news, on the Saturday morning before Easter 1865, of President Lincoln's assassination and the attempt on the life of General Seward's father, William H. Seward, Lincoln's secretary of state. In the messenger's haste to deliver the news, he did not stop his horse at the front door but rode right into the hall, finally stopping at the foot of the stairs. The horse's hind cleat marks were indented on the floorboards approaching the steps, and his front cleat marks were on the first three or four steps. When the building was torn down for the current library structure, the wood containing the horse's cleat marks was preserved and is today on display at the Triple Brick Museum at the Adam Stephen House property. Over the years, many different things were housed in this building—there were doctor's offices, insurance offices, et cetera. The former building was razed in 1966 for the construction of the current library.

I obtained the full story of the paranormal happenings here from five different people, and interestingly, each person's account of the events corroborated the others' recollections. As far back as in the 1970s, odd things were going on. The third floor, which was known as the mezzanine area, was the source of a lot of activity. When employees were closing up at night, they

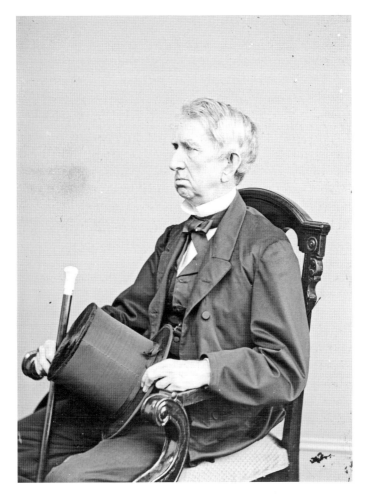

William H. Seward, President Lincoln's secretary of state and father of General Seward, the military governor of Martinsburg, whose military headquarters were located in the old Wiltshire Building. *Library of Congress, Prints & Photographs Division, Civil War Photographs.*

would hear the sounds of footsteps walking across the third floor and the sounds of chairs being pulled out from the desks and then being pushed back into place. Upon investigation, no one was present, and a thorough search of the facility revealed no one. This was particularly unnerving when renovations were being done and an extension was being added to the building. The entire third floor was sealed off, and no one could get up there, yet they would continue to hear the sounds of someone making his or her presence known. The smell of freshly brewed coffee would catch everyone's

attention as well; the smell would always be emanating from the third floor. The third floor also has a grand piano, and the sound of a single key being played would taunt the ears of those who heard it.

These seemingly strange yet harmless events soon took a turn toward the bizarre. Mysterious puddles of water began materializing in areas of the library. They would appear in the middle of rooms, never close to the wall and never on the ceiling—always in the midst of wide open floor space. People would see water actually running down the staircase from the third floor, yet upon inspection, they could not locate the source of the "spectral water." A plumber was called in to investigate the strange phenomenon to see if there was a leak or a plumbing issue at the root of any of this, but he was unable to locate any natural culprit for this most perplexing event and could offer no explanation. The front desk began getting repeated phone calls. When staff members would answer the phone, there would be a quiet, eerie little voice on the other end that would ask, "Is Mr. Wiltshire there?" Now what was particularly odd about these phone calls was that while the previous building's past association with the Wiltshire family was public knowledge, it was not common knowledge that just anybody would know.

The "disturbances" were not just confined to the adult library; the children's library had even more tangible activity. One of the librarians who worked there would often do the artwork for the displays, and on one occasion she set up a shadow box display with dolls depicting a "kitchen baking scene." The display had real flour in it on a wooden table, and the shadow box case was made of Plexiglas with a sliding door that was difficult for even the librarian to open. One morning, she arrived at work and noticed that the inside of the display showed signs of tampering. In the flour used for the display, there were the handprints of children who seemed to be playing with or interacting with the contents of the shadow box. The librarian would show filmstrips to children in the back room while she sat in the back. On more than one occasion, she would feel a light push from behind or feel her hair pulled; upon turning, thinking it was one of the children in the room with her, she would find no child behind her. She found out that, prior to her employment, several other people had seen a child or heard a child's voice speaking downstairs. She also heard footsteps sometimes when she was working alone down there on Sundays.

One night, an employee was closing everything up and heard the sound of footsteps running up the staircase from the children's library. He looked over at the door at the top of the staircase and saw a child's face looking at

him through the small window. When he opened the door and investigated, no one was there.

The librarian who did the artwork in the children's library was in the story room working with large sheets of paper and several pieces of chalk. The chalk kept disappearing, and she had to keep coming out of the room to get more chalk from the main desk. After this happened a number of times, she complained to her co-worker about what was going on. The next day, the co-worker came in and told the librarian that she knew where her chalk went. She went on to tell her that the previous night, she had needed something out of her attic and had her husband pull down the ladder. Upon doing so, all of the missing colored chalk rolled out of the attic, down the steps and onto the floor at her feet. She handed the pieces to her flabbergasted co-worker. This person lived in Shepherdstown, yet somehow the chalk had managed to transport itself to another geographic location!

Some of the staff of the library decided it was time to get to the bottom of all these strange and unusual experiences and began holding séances in the library after closing hours. With a Ouija board, they began trying to contact who or what was haunting this building. On one particularly unnerving night, around 11:30 p.m., the board kept spelling out the words "danger at midnight." They were unsure what exactly the ominous warning meant, so they decided to leave. Upon returning the next morning, they found a bullet hole in the glass of the front entrance door close to the drop box.

In the early '90s, the library's director brought in a psychic medium with the hopes that she would be able to contact the spirit/spirits. Everyone went to the third floor and stood in a circle, and the medium began to meditate. She said there was the spirit of a young man by the name of Jeff who had died in the previous building; he was a soldier during the Civil War. He was a mere teenager and had lost his leg in combat but had a peg leg replacement. Upon finding out this information, the employees chillingly realized something: one of the sounds they had repeatedly heard was what sounded like someone with a peg leg hobbling across the floor.

Employees researched the medium's claims about the spirit "Jeff," and no proof was ever uncovered to validate her impressions. The activity continued, and the employees decided to perform their own "exorcism" of sorts to calm the restless spirits and end the ghostly disturbances and manifestations. They went to the top of the building, lit candles and performed a ritual, and a feeling of peace immediately was felt by all. It seemed to envelop the library and shift its energy. They considered the exorcism successful because all activity ceased, and there have been no further incidents since.

So who or what really was causing these puzzling and, at times, astonishing phenomena? Some believed that a poltergeist was responsible due to the nature of some of the activity. The term "poltergeist" is the German word for "noisy ghost," and popular theory is that these are not the spirits of people at all; rather, they are the manifestations of people with strong, repressed psychokinetic and telekinetic abilities. When these people are under stress and have a lot of repressed anger or are undergoing emotional turmoil, they project these emotions, subconsciously, into the environment. This projection, or "entity," throws things, causes havoc, starts fires and engages in all the other destructive behavior associated with poltergeists. This phenomenon is often associated with adolescent teenagers who are under a lot of physical and emotional duress. Some of the phenomena at the library was "classic" poltergeist activity, like that present in famous documented poltergeist cases throughout the world: puddles of water appearing out of nowhere and objects disappearing and then reappearing in odd places. It was these events that led some to think that poltergeist phenomena were taking place. But if so, who was the agent of it? What, then, explains the activity that seemed like the behavior of a child? Who was the little child seen by one employee? Perhaps all of it was, as one eyewitness theorized, trapped energies from the former occupants of the old Wiltshire Building. Or maybe it was a combination of all those things. Whatever the case, it remains a mystery that, to this day, has never been solved and one that the eyewitness employees are not likely to ever forget.

Chapter 6

BELLE BOYD'S
EVER-FIGHTING SPIRIT

Belle Boyd is the most famous historical figure from Martinsburg and one of the most famous icons of the American Civil War. Commonly described as the "Cleopatra of the South" and the "Siren of the Secession," this colorful and rebellious Confederate spy grew up in Martinsburg. Belle's father, Benjamin Reed Boyd, built part of Lot 50 on the corner of East Race and Spring Streets on February 25, 1853. The Boyds moved into the Greek Revival mansion in 1854. From that location, Ben operated a general merchandise store, located on the west side of the house. In 1857, the home was sold, and the Boyd family moved to the south end of town, to the corner of South and Queen Streets, to a house located where the Silver House stands today. Only the house on Race Street exists today, and it is the only place still standing in Martinsburg where Belle Boyd actually resided. Now known as the Belle Boyd House, its brick exterior walls hold an abundance of rich history and perhaps some eerie reminders of its former occupants.

Even as a young child, Belle was a precocious, "spirited" young girl. When she was attending school on West Race Street, she and her schoolmarm, Miss Haven, did not get along. One day, Miss Haven decided she would not let Belle upset her any longer and decided to expel her from the school. She got one of Mr. Boyd's slaves to carry her desk and books all the way home and inform her father that she was not to return to the school ever again. In another incident, Belle's father was preparing for a dinner meeting in the ballroom of the Boyd House, and Belle asked if she could attend. Her father

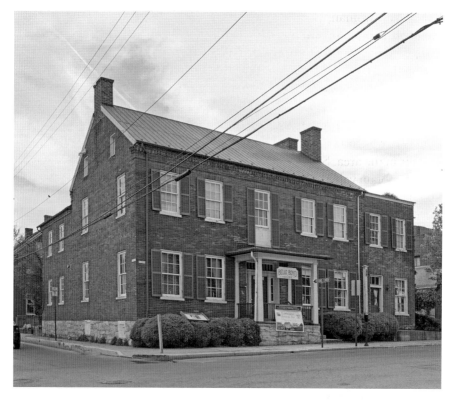

The Belle Boyd House, the former childhood home of infamous Confederate spy Belle Boyd. *Library of Congress, Prints & Photographs Division, photograph by Carol M. Highsmith.*

denied her request because she was not old enough. During the course of the dinner, all of a sudden, Belle came riding into the room on her pony and asked if her pony was old enough to attend.

During the Civil War, many people of Martinsburg were very Southern in spirit, and some were Confederate sympathizers. Belle Boyd and her family were staunch supporters of the Confederacy. When the Union army captured the town, whiskey flowed freely, and the soldiers began ransacking places, kicking in the doors to people's houses looking for Confederate flags, hurling chairs and tables out into the middle of the streets and generally causing chaos. They heard there was a young woman in the town who had her bedroom decorated with Confederate flags. They decided they were going to teach this young lady a lesson, and a drunken Union soldier showed up at the family's house to tell Belle's mother he was going to fly a Union flag over the home. This led to a controversial incident. Normally a meek,

soft-spoken woman, Belle's mother flatly refused and stated, "Men, every member of my household will die before that flag shall be raised over us!" When the enraged soldier began cursing Belle's mother and making threats against her, Belle took a pistol and fatally shot the soldier. Belle was only seventeen at the time and was acquitted of any wrongdoing because it was determined to be an act of self-defense. Some believe it was this incident that led to her hatred of the Union and to her campaign of betrayal against it.

Belle began using her "feminine wiles" and allure to deceive the Union soldiers in the area. She pretended to be on their side, all the while deceiving them to obtain valuable military information, which she committed to paper and delivered to the Confederate generals in the area. Belle made no effort to disguise her handwriting, and when one of the notes was intercepted, she was recognized as the culprit. She was simply given a warning and advised that she could be hanged for treason for this type of behavior. To keep her out of danger, Belle's father sent her to Front Royal to stay with her aunt and uncle. When the Union army headquartered in the home, once again Belle found ways to use the situation to her advantage. She hid in an upstairs closet and listened through a hole that had been bored into the floor when the soldiers were holding an important meeting. She then embarked on those adventures of espionage that made her infamous: risking her life, crossing battle lines on horseback and dodging bullets and danger to deliver information to Generals Thomas "Stonewall" Jackson and Turner Ashby. Her daring risks helped the Confederates recapture the town, and Belle was not only awarded the Southern Cross of Honor by General Jackson but also given captain and honorary aide-de-camp positions.

The fiery passion of Belle's "rebel soul" caused her to never stop fighting for the Confederate cause. The Confederate blockade runner *Greyhound*, on which she attempted to take a message to London, was captured. In the midst of these exploits and travails, Belle met and fell in love with her captor, Union naval officer Samuel Hardinge. He soon was proposing marriage, and Belle agreed to marry him with some conditions. First, he was to help the captain of the *Greyhound* escape; second, he was to resign from the Union navy; and third, he was to enlist in the Confederacy. Hardinge agreed, and they were later married in England. Belle's husband was dropped from the navy's rolls for neglect of duty in allowing her to return to Canada and then to England. Hardinge attempted to reach Richmond but was detained by Union authorities. Belle then sent her famous letter to Abraham Lincoln in which she threatened to write a book about her Civil War activities and include all the bad things done by the Union forces in Washington. Hardinge

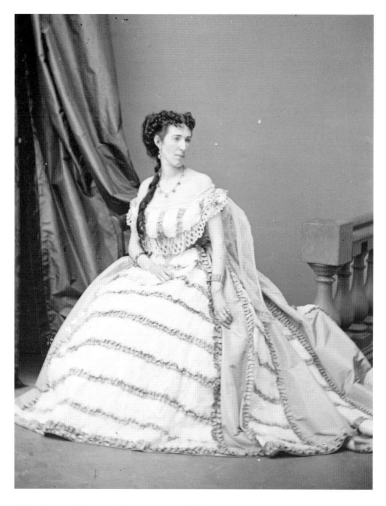

Belle Boyd. *Library of Congress, Prints & Photographs Division.*

was soon released and back in London; however, Belle soon learned he was having an affair with a girl named Fanny, and they divorced. Belle married two times after her divorce from Hardinge. Her second marriage was to John Edmund Hammond, by whom she had four children. She then divorced Hammond and married a young actor named Hugh High. Belle went on to become a stage actress, touring Europe and then the United States telling of her harrowing adventures during the Civil War. She died of a heart attack in Wisconsin on June 11, 1900.

Some believe that the ghost of Belle Boyd still visits the Belle Boyd House. The first "paranormal" incident occurred many years ago, when

the Berkeley County Historical Society had its headquarters there. A group of interns, given the project of redecorating Belle Boyd's bedroom, came in one morning and were shocked to find that everything they had placed on the walls—all the pictures—had been taken down and placed in a pile in the middle of the room. The interns set about replacing everything on the walls and rehanging the pictures. They came back in the next day, and once again, everything they had repositioned on the walls of the bedroom had been taken down and piled in the center of the room. This scenario happened one more time before they finally gave up and began work on another project. It could have been a prank, a result of someone's twisted sense of humor, but no one has ever identified the culprit or solved the mystery.

The Berkeley County Convention and Visitor's Bureau is now stationed in the house, and the staff working there will often smell the sweet scent of a woman's perfume when no one else is in the house. They also will often smell lavender, which seems to come out of nowhere and is strikingly tangible to the senses, even though fresh flowers are never kept in the house. The smell of bread baking often comes from the area where the kitchen used to be located and wafts enticingly through the house even though no bread is actually baking.

The sounds of disembodied footsteps are heard on the second floor of the house, as is the sound of a large trunk being dragged across the floor. Upon inspection, the trunk is always in its proper place, and no one is discovered on the second floor. The second floor is also where the old slave quarters are located; they house a collection of African American heritage items and exhibits. On the bed is a doll that is said to move of its own accord. When the house is empty, the staff from the visitors' center say they sometimes walk into that room and notice the doll in the center of the bed. When they walk by again, the doll has moved to another section of the bed, as if its sleep is troubled. The staff claims that when these incidents occur, no one has been in the house except for personnel. The room is also colder than any other room in the house, and no logical or natural explanation has been offered to explain the unusually chilly temperatures. People on this floor often report the eerie feeling of being watched or being followed by an unseen presence. It is not uncommon, when people have completed the house tour and are ready to depart, for them to ask the staff if the house is haunted because of the uncanny feelings that accompanied them throughout the quiet hallways and ancient rooms.

By far, the creepiest part of the house is the third floor, which houses the attic. On this floor, there are three rooms: two storage rooms and a cramped

middle room that has no windows. The staff makes a point to not use this floor, and the middle room, kept padlocked, is not accessible to the public. This room appears to have a heavy, suffocating atmosphere permeating it. Staff members get an unsettling feeling of dread on that floor—and for good reason. Once, when a man was returning down the staircase from having taken a box up to the attic, he was pushed from behind by unseen hands. After he regained his composure and his balance, he ran out of the house, never to return.

The house has been investigated by paranormal teams, and one group had a psychic medium with them. When they got to the ominous attic, the medium said she felt uncomfortable in the windowless room in the middle. She said she felt it was a place of confinement or a punishment room for the slaves and claimed she saw three slaves in shackles. When the group walked into the room on the right, one of the investigators was pinched from behind and asked the innocent person behind him if he was the perpetrator. The team had a recorder with them to capture electronic voice phenomena, and when they played the tape back, at exactly the moment when the investigator asked the person behind whether he had pinched him, another unidentified voice popped in to shout, "You're damn right!"

Perhaps the most startling piece of evidence captured from the investigation was a photograph that was taken of the front staircase of the house. In the photo, there is a reflection of a woman in the polished wood of the stairs, as if a woman were standing at the top of the staircase. Yet there was no one—no one mortal, at least—there. The woman was wearing a blue dress. According to legend, whenever Belle Boyd had a secret to tell, she always wore a blue dress.

It's difficult to say for sure who really haunts the Belle Boyd House. The house has had many owners over the years and, at one point in time, was divided up into apartments. If Belle Boyd still returns to this house in spirit, the question is why? She lived in the house for only a few years of her life, so why would she come back here? In her memoirs, *Belle Boyd in Camp and Prison*, she writes of her affection and pride for her hometown: "There is, perhaps, no tract of country in the world more lovely than the Valley of the Shenandoah. There is, or rather I should say, there was, no prettier or more peaceful little village than Martinsburg, where I was born in 1844." So perhaps it's those fond memories that keep her returning there, or maybe it's the excitement and adventure of fighting for the cause in which she so passionately believed that had its origins in Martinsburg. Then again, maybe she just enjoys spying on the living who now inhabit her former home!

Chapter 7

"GHOST ALLEY"

Situated on the corner of Martin and Queen Street sits an utterly beautiful and magnificent historic church. St. John's Lutheran Church has sat on that corner since 1832, with its gorgeous stained-glass windows and its spire and steeple towering high above Martinsburg. It's certainly one of the most visually dominating and commanding structures of the old town historic district. The present site of the Lutheran church was improved in 1854, with a large bell placed in the tower. During the Civil War, especially after the Battles of Gettysburg and Antietam, a lot of wounded soldiers from both sides were brought into the town, and many of the churches, as well as some of the other buildings, were used as field hospitals. St. John's was used as a hospital by the Union army, and like many buildings, it suffered a lot of wartime damage and much of it had to be rebuilt. The sidewalls are the only remnants from the original structure. The cornerstone for the current church structure was laid in 1884.

The alley directly behind the current church was once known by locals as "Ghost Alley." On March 14, 1947, the *Martinsburg News* column "Percolated" ran a story about an eyewitness encounter a local man had with a "ghost" in this little dead-end alley. Stewart McDaniel was a well-known African American janitor who took care of business properties in the first block of North Queen Street. One Saturday night, he was tending to the furnace of the American Store (a grocery store where the current WV Glass Company store is now located). It was sometime between 10:00 and 11:00 p.m. For some reason, Stewart was moving fast that night; he had

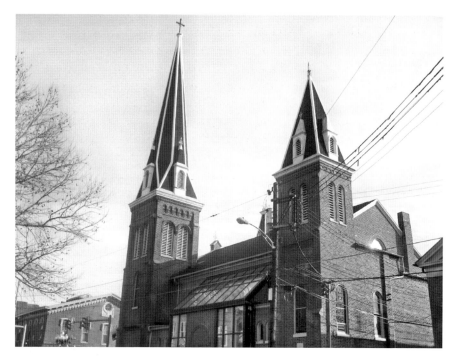

St. John's Lutheran Church, used as a field hospital by the Union army during the Civil War. *Photo by Justin Stevens.*

an eerie, unshakable feeling that something was not quite right. There was something in the air.

As he stuck his head up out of the back cellar stairs, he saw a woman walking down the alley without making a sound. He didn't see how this was possible, for it was the middle of winter and the alley was covered with ice, yet she walked down the alley effortlessly, without slipping or losing her footing, as if the ice were not even there. The woman had on some kind of dark coat or cape that fell just below her knees. Stewart could see the bottom of a white dress, as if she were dressed in a nurse's uniform. He was about to say something to her; it looked kind of suspicious. What was she doing in the alley at that time of night? Was she up to some kind of mischief? But before he could catch his breath, the woman disappeared. She just melted away only a few feet away from him. Stewart could not believe what he had just seen! Perhaps his eyes were playing tricks on him. He walked to the mouth of the alley, thinking perhaps she had somehow managed to get to Martin Street. He asked a passing pedestrian if he had seen anyone emerge from the alley, but the pedestrian said nobody had come out of the alley.

Stewart told his story to several people who live near the alley. They told him the alley was "like that." It has been haunted for years. One woman asked if the woman had a big dog with her. Stewart said he had seen only the woman. "Then," said the woman, "you have not seen all of it yet. That woman usually has a big dog with her." Stewart had been going in and out of that alley every night for the past two months, sometimes at the bewitching hour of 3:00 a.m. Never before had he seen anything unusual. Certainly, he had never noticed anything unearthly. But there was no mistaking what he had seen on that cold, wintry night. Stewart was quite philosophical about his experience. He accepted it as something that just *is*, something that can't be changed. The only thing to do was make the best of it. However, Stewart decided he would probably never be going in or out of the alley at 3:00 a.m. anymore. He wasn't too concerned about working around there at 10:00 p.m.—there were still a lot of people stirring at that time of night—but not at 3:00 a.m. The locals named the alley "Ghost Alley" as a sort of protective warning to those who might be tempted to enter it at a bewitching hour.

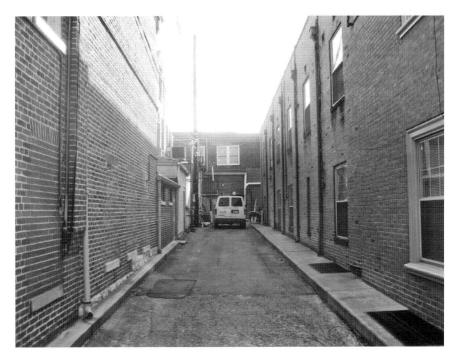

"Ghost Alley," located behind St. John's Lutheran Church, where a ghostly nurse has been seen late at night. *Photo by Justin Stevens.*

So who was the spectral woman, and why does she continuously walk through this dark, lonely alley in the middle of the night? At the time of this newspaper article, the only hospital in operation in Martinsburg was the King's Daughter's Hospital. It's safe to assume the woman was a nurse there, but that still doesn't shed any light on her eternal journey through the alley behind the Lutheran church. Why is a large dog sometimes walking with her? Perhaps it's a "residual or imprint" haunting—an image or emotional event from the past that is "spiritually" branded into the environment. If one believes these paranormal theories, perhaps this woman and her dog are simply images from the past, unaware of those from the present who observe them reenacting the same event in an eternal, ethereal loop.

Chapter 8

PERFORMANCES FROM THE AFTERLIFE AT THE APOLLO THEATER

Most small towns have a local landmark of which locals collectively have many fond and cherished memories, and in Martinsburg, for many, that place is the historic Apollo Theater. Many recall seeing their favorite films for the first time in their youths in the building's auditorium or experiencing the thrill of performing on stage in front of an enthusiastic audience. Sweeping memories of elegant dances and parties in the Roseland Ballroom or the satisfaction and comforting feeling of being part of a community sometimes colors people's recollections of this establishment. One thing is for sure: cherished memories and happy events remain forever etched in one's mind, and for many, this theater was the source of a lot of warm, sentimental feelings of growing up in a small town.

The theater was built in 1912 by a successful businessman, Harry P. Thorn, and it was originally known as the Thorn Building. The design of the theater was a collaboration between a local architect by the name of Chapman E. Kent and Reginald Geare. After the Apollo, Geare went on to design several other theaters in the D.C. area, including the Knickerbocker Theater. When the Apollo opened, its seating capacity was one thousand people. It originally had a smaller stage and orchestra pit than it does today. The first floor is where silent movies were shown during the 1920s, accompanied by music played by Mary O'Rourke at first on a piano and then, later, on a Møller organ. When talking motion pictures evolved, the theater was wired to accommodate this. The second floor housed the Roseland Ballroom,

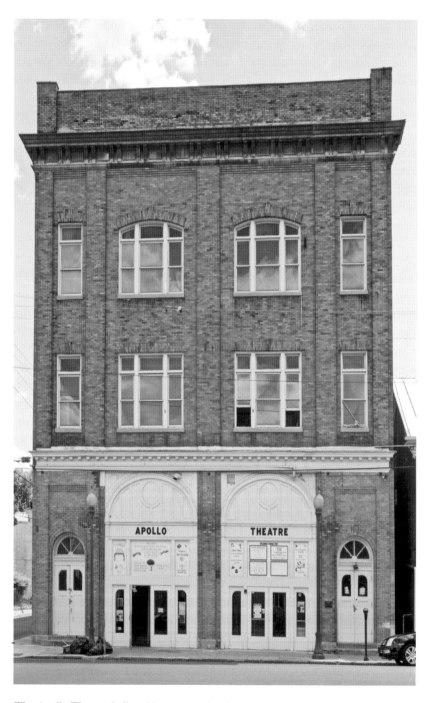

The Apollo Theater, believed by many to be the most haunted building in Martinsburg. *Photo by Acroterion.*

where elaborate dances and parties were held. The third floor contained Thornwood Hall for community social and entertainment affairs. One thing that set this theater apart from others in the area at the time of its inception was that, in addition to showing films, the theater also held vaudeville shows, which made it much more than just a movie house.

Another common memory people have when asked about this theater involves experiences with "ghostly" inhabitants of the building, and most people either have a personal story to tell or know someone who has had what they believed to be an "otherworldly" encounter. In fact, the Apollo is believed by many to be the single most haunted building in Martinsburg. Wisely, the folks in charge of the theater have chosen to capitalize on its paranormal reputation and offer paranormal and overnight investigation opportunities to the ghost-hungry public. It's a popular destination for ghost hunters today.

I want to share with you a common scenario experienced by many people over the years: Someone is sitting in the audience during a performance, and her eyes travel up to the balcony. She sees a man standing there wearing a brown checkered flannel shirt and bib overalls. He has facial hair and is smoking a cigar. Now, there are two things wrong with this scenario. For one, there is no smoking allowed in the theater. For another, as she is looking at him, he vanishes into thin air. The spirit is known as George, and to the people who have spent a lot of time around the theater or who grew up in it, George is very much a part of the facility and is just like an old friend. When actors and actresses are rehearing in the evenings and the seating in the "house," as it is known, is empty, they will sometimes see this man sitting in the audience, observing them and continuously puffing away on his cigar. The strong odor of cigar smoke is how George makes himself known, and areas of the theater often reek of the distinct aroma of cigar smoke when no one is present. George is widely believed to be a friendly, protective spirit who just seems to love the theater and watches over those who contribute to its ongoing success. On occasion, though, he has been known to get a little mischievous.

When the movie *Gods and Generals* was being filmed in this locality, the Apollo was selected as the setting for the scene in which President Abraham Lincoln observes a performance by John Wilkes Booth. A female reenactor dressed in Civil War garb went to use the lady's restroom. She came bolting out of the door, screaming in terror. When asked what had happened, she stated that a man dressed in overalls and a flannel shirt with a beard was standing in there smoking a cigar. Upon investigating the restroom for any

sign of unwanted visitors, no one was found, and no one had exited the restroom. It was believed that George had made another appearance, but this time in an inappropriate room! People have reported a similar-looking gentleman wearing a white suit jacket smoking a cigar up in the balcony. Does George appear in various attire? Or is it simply another actor who returns and enjoys performances? No one knows for sure.

The folks at the theater started referring to the ghost as George many years ago. No one seems to know why—it was just a name that was randomly chosen to identify the resident spirit. Legend has it that George was either a stagehand or a stage manager, and on one particular occasion long ago, he was up on a ladder trying to fix or adjust the lighting. As he was doing so, he lost his footing, fell off the ladder and plummeted to the stage floor below. He either died there or was severely injured and taken from the theater and died shortly afterward. Another version that has been tossed around is that he was up on the catwalk trying to fix the lighting, lost his footing, fell and got tangled up in the ropes dangling about, inadvertently hanging himself. Regardless of which version of the story you believe, some people claim it's all purely urban legend, and there is no record of anyone ever having died in the building. However, there could be another possibility to consider when trying to determine who George was in life. In 1913, one year after the theater was built, a policeman was chasing a man who was resisting arrest from the train station. He shot and killed the man right at the corner of this building. It's perhaps no coincidence that the man's name was George. Perhaps at the time of his bodily death, his spirit found the refuge that it was seeking within the walls of this theater, and this is where he has stayed ever since.

Another story circulating about the theater is that a place of "ill repute," or a brothel, was once located where the stage sits today. In the 1800s, it is said that there was a fire, and all of the patrons inside were killed in the flames. People say that those so tragically killed in the fire still return to dance on the Apollo's stage, and you can smell what seems to be smoke from smoldering flames in the stage area. Sometimes you can hear the sound of cabaret-style music echoing through the theater from the "house" area. People using EVP recorders claim to have captured disembodied female voices with distinctly flirtatious tones saying things such as, "Hi, honey," or "Come over here, honey." It's believed that these are voices of the "ladies of the night" from the former brothel still trying to engage their male customers. Prior to the Apollo being built, it is said there actually was a livery stable and a tavern located at this site. Perhaps this tavern was actually the brothel. Regardless,

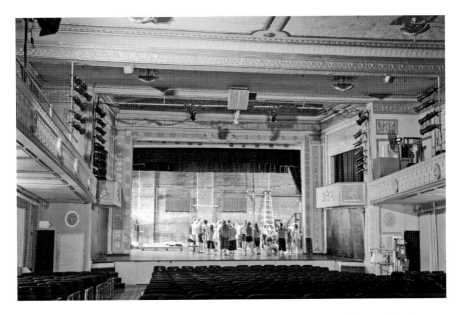

The "house" of the Apollo. A brothel is said to have once stood where the stage is today. *Photo by Acroterion.*

the fire said to have consumed it that created the ghostly visitors has never been substantiated.

There are also spectral children said to roam the rooms and corridors of the theater. The sounds of footsteps running around the theater and up and down staircases and playful giggling of a child lead many to believe there is a ghostly children's game playing out in the theater.

In 1918, there was a devastating outbreak of Spanish influenza that swept across the country and held the town of Martinsburg in its grip of terror. Five hundred people died in Berkeley County during this outbreak, and one hundred of those people died in one day. People were dying on a daily basis, and there were few funerals during this time because family members were often too ill themselves to attend the funerals of loved ones tragically struck down by the illness. It is said to have been one of the saddest and most horrific events in the history of this town and one that the town will never forget because of the horrific impact it had and the deaths it left in its wake. It is rumored that the third floor of this building was used as a temporary hospital for those affected by the deadly virus and that perhaps these ghostly children were a few of the many victims this epidemic claimed. Perhaps they are searching for their mothers, from whom they were so suddenly and cruelly separated when the illness took them at such tender young ages.

Other entities seen here are known as "shadow people" or "shadow figures." Shadow figures are believed to be another type of haunting, and the theories behind them are as a vast as the Apollo's rooms. They are said to appear as solid black figures in the shape of a person but with no features or distinctions. Some say they have red eyes; others claim they wear large, broad-brimmed hats. It's theorized they are merely the spirit of a person who does not want his or her identity known or that they are the epitome of evil with diabolical intentions. Some even speculate that they are beings from another dimension—what are known as "astral entities." Whatever they are, these shadowy forms have been seen on the Apollo's stage and up in the balcony. The theater's director was reportedly up on a ladder doing some repair work one night. He was alone when, all of the sudden, a formless, featureless shadow came running across the balcony, directly past his vantage point. He was so scared that he got down off the ladder and ran out of the theater.

Speaking of fright, the third floor was at one time considered a forbidden area because the events that transpired up there were so terrifying. The story goes that in the 1980s, a group of kids broke into the theater one night and went up to the third floor to use a Ouija board. They encountered a malevolent spirit and were so horrified that they tore out of the building, running for their lives. This "spirit," however, remained behind. A drama teacher, a no-nonsense woman not given to wild imaginings, on one occasion ventured up to the third floor. The third floor is a vast area used for various things. There is one room known by theater veterans as the "attic," where props, set pieces and costumes are stored. There used to be little light up there, and a flashlight was necessary to find your way in the darkness. The drama teacher entered the area, and while she was in there, she saw two bright red eyes glowing among the set pieces in the darkness. She claimed she was so scared that she refused to ever go up to the third floor alone after that experience. She had never felt such a crushing feeling in all her life. Whatever it was, it was evil. She rarely spoke of the experience; if she did, it was with great reluctance.

Many other people had the same experience with the red eyes. It would seem as if they would move closer and closer, giving one the overwhelming feeling of being watched and chased. Objects would also move of their own accord, and then people began seeing another apparition. A man would appear wearing a long, dark coat and a wide-brimmed hat. He would continuously walk across the large third-floor space. His identity was not known, but it was suggested that perhaps he was another spirit brought forth from the Ouija board, and he was trapped and could not leave. No one

would enter the dreaded area alone. Eventually, a priest was brought in, and he performed a blessing in an attempt to eradicate the horrifying entities and end the disturbing experiences. It is said that there have been no further incidents since.

For some spirits seen in this theater, no identity has been uncovered, and they appear to be passing entities coming and going. A woman in a white wedding dress has been seen by many people, but no one knows who she is. Other strange, random events continue to this day to perplex patrons, theater staff and volunteers. One of the entrances to the underground tunnels was uncovered in the last few years under the structure. A psychic medium who once visited the theater said the tunnels act as a portal for spirits. She theorized that that is why there are so many spirits in this historic gem. However, it seems much more likely that they're former patrons or participants from the theater's long and well-established past as a significant contributor to the heart of Martinsburg and its community. Perhaps in the afterlife, they return to where they were happiest in life. One thing is for sure: the Apollo Theater continues to be a place of entertainment for both the living and the dead!

Chapter 9

GHOSTLY GUESTS AT THE SHENANDOAH HOTEL

Located on Martin Street, the same street as the Apollo Theater but up one block, sitting on the corner of West Martin and North Queen Streets is another Martinsburg landmark: the Shenandoah Hotel. Prior to the hotel's establishment, this corner was the site of the old Central Opera House, which was destroyed by fire in 1919. Community spirit was said to have been the driving force that launched the idea of a downtown hotel in Martinsburg in 1922, and community loyalty funded it. The hotel received its name from a contest in which citizens entered their suggestions. The hotel opened on Washington's birthday, February 22, 1926, to much excitement and elation. Over three thousand lunches were served on that opening day, and local history books contain photographs from that celebration, showing the sidewalk alongside the hotel mobbed with crowds.

The hotel was once recognized as one of the top hotels in the Shenandoah Valley. It was considered the first upscale facility of its kind in Martinsburg when the doors to this grand and spacious establishment opened to the public. The building features an impressive, elegant lobby that greeted visitors upon first crossing the building's threshold. A massive and spacious dining room adorned by stunning crystal chandeliers set the mood nicely for weekly meetings of local cotillions, clubs and groups; weddings; and even nurses' graduations. The adjoining grand ballroom was more than well equipped to handle any soirée of any capacity or demand with its lovely décor and inviting atmosphere. The hotel housed a total of 140 rooms, in addition to the dining room and ballroom, and according to local author

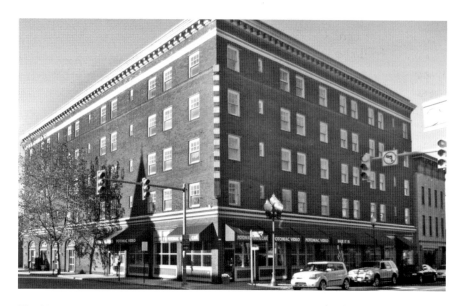

The Shenandoah Hotel, where celebrities such as Lucille Ball and Debbie Reynolds were guests. *Photo courtesy of David Wilt.*

Ethel Wayble Bovey's book *Hometown Memories (Growing up in Martinsburg, WV)*, the most expensive room offered at what was also referred to as the Hotel Shenandoah was a double with a bath and shower. It was available for a mere $3.50. With a prime location between West Virginia 9 and U.S. 11, through-traffic stopped at the hotel often for meals, which were advertised as "excellent cuisine" at "coffee shop prices." Many locals fondly remember the hotel's "watercress salad." The bellhops were said to have been dressed in red uniforms, further adding to the overall "class and elegance" of the hotel.

Through the years, it was the scene of social, political and commercial events. Visiting dignitaries and local, state and national political figures have been fêted in the dining room and ballroom. The establishment has also entertained some celebrities and Hollywood royalty throughout its tenure as a hotel. In her early years, the famous actress Debbie Reynolds (mother of Carrie Fisher, who portrayed Princess Leia in *Star Wars*) spoke to a United Nations banquet in the dining room and is said to have been a guest on several occasions. Constance Bennett, an actress in early silent films and then in talking pictures, also appeared at a United Nations dinner at the hotel and was interviewed by local author Ethel Wayble Bovey. Lucille Ball, film actress and star of the beloved sitcom *I Love Lucy*, was a guest here in 1964. She was the grand marshal of the Apple Blossom Parade in Winchester, Virginia, that same year and stayed at the hotel. Robert Kennedy spoke to a session of the chamber

of commerce here. Old Hollywood actor Raymond Massey, Jay Rockefeller and John Ford also were famous personalities who passed through the hotel's doors. Despite the hotel's popularity, the need for a downtown hotel decreased over the years, and in the 1970s, the hotel closed. For a brief time, it underwent a name change and was known as the Gateway Inn. Renovations and restoration began on the historic landmark several years ago, and the first floor of the hotel has been lovingly restored. Annual local events such as the Book Faire, Rotary Club dances and receptions for the local annual Apple Harvest Parade Queen are held in the building.

Walking through the hotel today and admiring its gorgeous architecture and design, one can almost glimpse the many colorful personalities and pivotal moments from people's lives that have transpired here over its illustrious past. Like the Apollo, many locals have personal stories and histories associated with this once-glorious hotel. In the fall of 2015, with the gracious help and permission of the building's property manager, David Wilt, I offered a special Haunted History Tour of Martinsburg, which took patrons inside the hotel for a special indoor tour. The response and interest we got from locals on this particular tour was absolutely astounding, and if I needed any confirmation beforehand, it was certainly more than confirmed that night that the public is still interested in and has very close ties to this building. Beneath all the glitz and glamor, like at any self-respecting, historic hotel with a long, storied past, there are also believed to be a few "guests" that have never checked out. Haunted hotels pop up in the lore of many small towns and cities. A prime example of the quintessential haunted hotel story in popular fiction is author Stephen King's novel *The Shining* and the memorable 1980 film of the same name starring Jack Nicholson.

According to local legend, prior to the hotel's existence at this location, there was a house that stood directly in the center of the hotel, where the ballroom stands today. During the Civil War, when a skirmish was taking place near the area, the woman who lived in the house made the mistake of stepping out into her backyard. Upon doing this, she met with a stray cannonball and she, and the house, were both tragically blown to bits in the explosion. I have found no documentation to back up this story; however, in a diary kept by Betty Hunter during the Civil War in Martinsburg, there was an interesting entry that stated, "One poor woman who ventured out yesterday was killed by the explosion of a shell." However, it didn't give the woman's name or the location of her death.

This entire area of the hotel, which includes the ballroom, kitchen and surrounding area, where the house was said to have been located is

considered to be the most paranormally "active." The property manager's nephew, on one occasion, was alone in the building and was walking down a hallway on the other side of the wall of the ballroom. As he was traveling down the hall, he noticed that following behind him was a woman. She appeared to be an older lady with dark, longish hair, and she was wearing a white top. However, he noticed that she was visible only from the torso up. This half-formed female apparition trailed him down the entire length of the hallway. When renovations were being done to the hotel many years ago during restoration, many of the workers in the ballroom, especially around the back wall where the kitchen is on the other side, had some strange and sometimes hair-raising experiences. They would see what appeared to be a lady dressed in white passing by them out of the corner of their eyes, and they would feel the light touch of a hand across the backs of their necks. The grand piano that sits in the opposite corner would also begin to play by itself, but it would be the sound of only two keys being played.

Several years ago, in the front part of the building, there was a video store named Potomac Video. Down in the basement is where all the old VHS videotapes were housed. The store manager, the current property manager of the building, installed a security camera with a microphone to monitor theft or any suspicious activity. When the recording was played back from the previous night's surveillance, it revealed the sounds of movement and what appeared to be people walking around in the basement, as well as the sounds of videotapes being moved or shuffled around, yet nothing was revealed on film as the catalyst. Videotapes were constantly being found out of place and in disarray when no one was down in that area. The employees would keep the microphone turned down during business hours because they were unnerved by the sounds that would emanate from down in the basement when customers were not down there.

One Halloween, the employees from the video store decided to have a Halloween party in the hotel. About a week later, they decided to have a séance to try to contact the spirits that haunted the building. On the night of the séance, they arrived at the hotel with a spiritual medium. When they entered the ballroom, they were chilled to the bone when they saw a Halloween mask that had been left in the hotel from the previous week's party floating about twelve feet in the air above the grand piano in the corner. It was the famous mask from the movie *Scream*, and as if that image is not already frightening enough, imagine seeing it floating in mid-air of its own accord! The group moved into the kitchen as the séance progressed, and things began to get eerier. The atmosphere

seemed to become charged with a thickness—a palpable sense of the hotel coming to life, so to speak.

The property manager's nephew was aggressively pushed by an unseen presence up against a kitchen cabinet. This leads us to another "spirit" said to inhabit this area of the hotel. There is a large walk-in freezer located in the kitchen. Several years back, a group of ghost hunters conducted an investigation of the hotel and claimed to have uncovered a dark presence in the area of the freezer. They claimed to have captured the image of a scary, "demonic"-looking face. They claimed that this entity hides in the walk-in freezer, and it comes and goes through there. The property manager says that frequently the door to the freezer opens of its own accord. It locks securely in place with a resounding "click" when it's closed and will not open without strong manual intervention. Yet it will often be found standing open; if someone closes it and walks through the area shortly thereafter, it often will be found standing open once again. Former hotel managers and the property manager's daughter, who spent a lot of time around the hotel since her father worked there, say the area always made them uncomfortable and seemed to have a heavy, negative energy to it. The night we held the tour, a lot of participants seemed uncomfortable in that area, and some individuals who are "sensitive" reacted quite strongly to this area. They claimed the area and its energy was "suffocating" and dark in nature.

A worker who was up on a ladder during the renovations claimed that something tried to push him off the ladder. The presence that pushed him was not visible, but he could clearly feel the physical force of it, and it was strong enough that he started to lose his balance. Thankfully, he regained it before he plummeted to the floor below. It's believed that this dark spirit is responsible for some of the more violent physical attacks people have reported.

Another story about the hotel is that two young girls were playing on an upper floor and accidentally fell down into an elevator shaft and were tragically killed. During a ghost investigation years ago, a couple female participants went up to the floor where this tragedy was said to have occurred. These women felt as if something "possessed" them. They suddenly began behaving and playing like little girls and had no control over their bodies or their actions. It was only later, when they shared their experience of what had occurred, that they learned of the legend of the ghostly little children.

This location of Potomac Video was also the location of Dolly's Bake Shop for a couple of years. Dolly and her staff were not immune to unusual occurrences, either. On one occasion, a large pack of Deer Park water, the value-sized pack, was placed on top of the refrigerator in the kitchen. While

the owner was out front, she heard a large crash come from the kitchen. Upon investigating, she discovered that this heavy, large pack of water had been pushed off of the top of the refrigerator to the floor below. The front door has a buzzer that goes off when a customer enters. On several occasions, the buzzer went off, indicating a presence, but no customer was at the door, and there was no sign of any human presence. In a rather humorous incident, the owner was in the shop alone in the evening and had locked the front door. She went to use the restroom located in the hotel area. She left the connecting back door from her shop to the hotel open because it was an automatically locking door. Upon returning from the restroom, she discovered the door had closed itself, and she was locked out of her own shop. She had to go down to the basement and out the other way, then go to the flower shop a few doors down to use the phone to get her husband to bring her the spare key so she could get back in. On yet another occasion, when she was not present, employees reported that the lid of the garbage can lifted up, taking on a life of its own, so to speak, and began floating around the store. Luckily, there were no customers present when this took place.

So it's anyone's guess who or what is behind the "hauntings" and these seemingly supernatural events. We have the back stories that have been passed down from one generation to the next that give life and identities to the specters. Historically speaking, there has never been any proof to back up any of the claims about who the "haunting" spirits are. But one thing is for sure: whether or not the stories behind the ghosts are true, to the people who have witnessed the many "uncanny" events that I've chronicled in this chapter, the experiences are all too real!

Chapter 10

THE DEVIL AND THE DOCTOR

Sitting on the southeast corner of East John and Queen Streets is a small, brick, rather nondescript-looking building. It is situated diagonally across from the stunning St. Joseph's Catholic Church, the most visually arresting structure on that particular block. Prior to this small building accenting this corner, there was a church that stood at this spot. The Central Church of the Christian Disciples of Christ was located here, and information regarding it seems to be quite scarce. From what I've been able to gather, it was a totally different structure with a stucco exterior, and it was torn down for the building of the current structure. It was first listed in the old city phone directories in 1920, and the last year it was listed was in 1960. Prior to the church's existence on the corner, there is said to have been a house at this particular spot. The basement of the current building is said to have been the first floor of the house. For example, when the church was located here, when you were in what is now the basement and opened the outside entrance door, you would walk out onto the sidewalk. When you open that same door now, you encounter a wall of dirt. So what is now the basement was originally the first floor, and the pavement and the street have been built up and developed over time. A baptismal pool from the church is still said to be located down in the basement.

Many years ago, when the church was torn down, the current building was erected as an optometrist office, and a framed picture of the church was proudly mounted on the wall in the office. As I stated previously, this is a rather ordinary looking building; however, appearances can be deceiving,

The former site of an optometrist's office and where a church was previously located. *Photo by Justin Stevens.*

and a chain of horrifying events unfolded here that was very much out of the ordinary! Shortly after the office opened and business commenced, the staff began noticing a variety of subtle yet nerve-jangling events. They would hear what sounded like voices arguing coming from the back of the building, and at other times, it sounded like a multitude of voices in unison, as if a congregation were holding a service. When they arrived in the morning and opened the office, the stereo, which had been turned off the previous evening when closing up, would be found turned on. Another eerie finding upon opening the office would be evidence of someone, or something, having typed on the typewriters. What was particularly alarming about this was that no actual words or sentences would be typed out on paper, just letters and what appeared to be illegible gibberish.

These seemingly "unnerving yet harmless" happenings began to take on a more visual component. An employee was smoking a cigarette in the office (this was back in a time when smoking in public buildings and businesses was allowed) when an unseen hand suddenly smacked the ashtray out of the individual's hand and caused it to go flying across the room. The doctor had

something stuck in his finger; he was in his office trying to pry the foreign object from the skin when he noticed, in his peripheral vision, a young girl standing in the doorway observing him. When he turned around to face the unexpected visitor head on, his eyes met an empty doorway. Visions of an elderly woman dressed in what appeared to be a nurse's uniform began plaguing the staff. For example, the doctor would be servicing a patient in his office, and he would see this woman, also standing in the door, silently looking over his shoulder, appearing to be very concerned about what he was doing. His secretary and his assistant begin seeing the strange visitor as well.

Things really took a turn that made everyone in the office realize things were not quite as they seemed. The secretary and the doctor's assistant began seeing exact doubles of each other. For instance, when the secretary would be up front in the reception area, the assistant would see her in another area of the building, only to find that in reality, the flesh and blood secretary was in the front reception area. The secretary had the same experience with the assistant, seeing her in another area of the building only to find that the living, breathing person was elsewhere. They were experiencing what they believed to be a phenomenon known as "doppelganger." The term is said to be a German word meaning "double-goer" and refers to a wraith or apparition that casts no shadow and is an exact replica of a living person.

The doctor had two dogs that he would sometimes bring into the office with him. The doctor's office was directly across the hallway from another office that was situated directly over the area of the basement where the baptismal pool was located. These two canines would absolutely refuse to cross the hallway from the doctor's office into that room located across from it; they would freeze in place and would not budge. They would simply stare as if they saw or sensed something they didn't want to come in contact with. Down in the basement, there were still a few items left behind from the church's tenure at that location. Books with Bible verses, hymnals and such things were still stored down there. The doctor decided he was going to donate them to an individual or another church, so he headed down the stairs that led into the dark, dank basement beneath. After he had retrieved the items, he walked back over to the foot of the staircase to begin the ascent to the top. He had placed his foot on the first step when an ear-shattering scream resounded through the musty recesses of the room. The scream had such tremendous volume that if someone had been walking past the building on the pavement above, they surely would have heard it. He said the scream was "indescribable"; the best way to attempt to articulate what it sounded like would be to say it was like "a cross between a human scream and an

animal shrieking." He said it sounded "ungodly." Well, rather than fleeing up the stairs and retreating in terror, the brave doctor decided to confront the entity. In a strong, challenging tone, he shouted, "What are you? What is it you want? If you want something, come after me!"

After this horrific encounter with the invading spirit, the staff at the office believed that they were dealing with something far darker and more dangerous than any of them could have imagined. They felt it was what the Catholic religion would call a demon. A demon is believed to be a spirit that has never walked the earth in human form, and its sole purpose is said to be to cause misery and destruction among mankind. With this compelling revelation, the doctor turned to a Catholic church for help and feared that a harrowing spiritual battle between good and evil was about to play out in his quaint little office. The church decided that an exorcism was needed to eradicate the evil intruder. When most people hear the term "exorcism," the image that immediately comes to mind is Linda Blair's head spinning and spewing up green projectile in the classic 1973 film *The Exorcist*. Exorcism is an ancient ritual that is said to banish evil spirits and demons from places and people they have possessed. It is a controversial rite that has long been associated with the Catholic Church, which only occasionally administers it in modern times. The exorcism in this case was "unofficial," since an "official" exorcism has to go through proper channels in the church and be church sanctioned.

When church officials arrived and began reciting the exorcism rites, they went to the doctor's office and asked him to kneel down on the floor so they could lay hands on him and pray. The doctor's desk was a big metal table, and it suddenly began to shake violently. To everyone's shock, this heavy metal desk began to levitate, lifting off the floor several inches. The exorcism was not a success, and the activity worsened. The doctor's wallet disappeared, and he searched the entire office and every nook and cranny he could think of where it could possibly be hidden or misplaced. He went out to his car parked in front of the building and searched it—still nothing. So in broad daylight, in front of the building on the public sidewalk, he decided to confront the entity yet again. He defiantly said to unseen ears, "So you showed me you were strong enough to make my wallet disappear. How about showing me you're strong enough to make it reappear?" Later that evening, the doctor and his wife made an astonishing discovery. In the doctor's bedroom, stuffed behind the dresser, was an old pair of trousers that the doctor had not worn in years. In the pocket of these trousers was the missing wallet.

The activity never ceased, and some claim that the tormenting spirit followed the doctor and continued its reign of terror in his home. The spirit's origins, and why it besieged that plain, mundane little building on that corner, is an enigma that to this day has yet to be solved. This man was a well-respected and well-liked citizen in the community. He had a successful business and was actively involved in his church, where he taught Sunday school for forty years. He and his staff, however, were thrust into extraordinary circumstances, where they believed they experienced something profound. As for the building's current status, today it sits empty and abandoned. Only time will tell what the future holds for it and for any future occupants.

Chapter 11

JASPER THE FRIENDLY GHOST AT CITY NATIONAL BANK

On the corner of South Raleigh Street sits a high Victorian Gothic–style building that is, in my opinion, one of the most architecturally interesting buildings in all of Martinsburg. And its architecture depicts its original use. It is the original site of the third Berkeley County jail erected in Martinsburg. When the second county jail was purchased by the King's Daughter's group and converted into a hospital, as mentioned in Chapter 2 of this book, a new jail was needed. The Martinsburg Manufacturing, Mining and Improvement Company was on the southwest side of Martinsburg and purchased several hundred acres. On January 9, 1892, the Berkeley County Circuit Court purchased a lot in the 300 block of South Raleigh Street, where the new brick county jail was completed by July. It is listed by the National Register of Historic Places as part of the Boomtown Historic District of Martinsburg. This new jail served the county in that capacity for almost one hundred years. When the new Eastern Panhandle Regional Jail was established, the operations of the Raleigh Street building were phased out. The building was purchased years ago and then renovated for its new incarnation as the City National Bank, which is currently located there today.

One of the most visually arresting features of the building is the tower that extends above the rest of the facility. It is said that in the top of the tower is a gallows, where prisoners were executed by hanging. The branch manager of the bank said the structure is still located in the top of the tower, but it was sealed off when the renovations were done for the bank so none of the

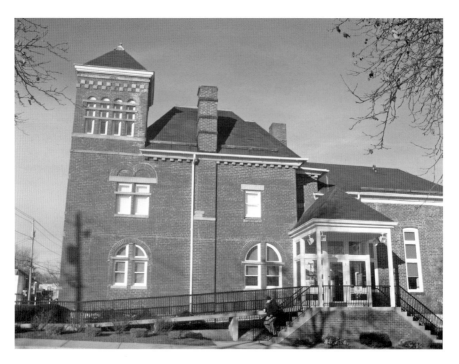

City National Bank, where the third Berkeley County jail was located for nearly a century. *Photo by Justin Stevens.*

employees have ever seen it. They tell me at the Berkeley County Courthouse that only about two or three people were actually hanged there. If you go into the bank today, you will see an interesting reminder of the building's history. A shadow box display case is mounted on the wall containing old relics from its former use, such as the jailor's keys, the rusty old shackles and the hangman's noose. These items were donated to the bank by a former sheriff when it took over ownership of the building.

Back in the old days, when homeless people or vagrants would be found at the B&O Railroad Station, they would be brought to this jail, fed and provided with shelter from the elements and the degrading and inhumane conditions they were living in. The story goes that one Sunday, a man was discovered at the train station who was in a terrible state of health and was close to death. He was suffering from malnutrition, was extremely weak and sick and badly needed the intervention of human kindness and caring. He was brought back to the jail and put in one of the empty cells, where he would be able to rest in a safe environment, protected from the elements. The cook immediately went to the kitchen and began preparing a meal

consisting of beans and cornbread to provide his frail body with the much-needed nourishment it was lacking. When the meal was prepared, the jailors went to the cell to retrieve the man, only to discover they were too late. The poor man had starved to death.

The following Sunday, the cook came out into the kitchen to prepare a meal for the prisoners as he always did. As he was shuffling about the stove, he had the distinct feeling of being watched. He turned around, and there was a man sitting at the kitchen table. The man had longish, unkempt-looking hair; a long, overgrown beard; and a very tired, worn-out appearance. As the cook stood there fixating his attention on this silent person sitting at the table, he realized it was the man who had died of starvation the previous week. But he couldn't believe his eyes. The man had died—how could he be sitting at the table in the kitchen in the present? As he strained to wrap his mind around what he was seeing, trying to make logic out of something completely illogical, the man at the table vanished from sight. It's said that from then on, every Sunday, when the cook would come into the kitchen to prepare food, this same man would always appear, sitting at the kitchen table as if he were waiting for the meal he never received. The back part of the building where the kitchen was located was torn down in order to make extra room for the parking lot of the bank. On one Sunday, when the bank employees were preparing for grand opening day, one of the employees went up to the storage room located in the tower. When she entered the storage space, she saw a table with a man sitting at it. The man had the same features and appearance as the man who had been visiting the jail's kitchen in spectral form every Sunday for many years. There was no physical table in that particular room, but she saw one clearly with the sad, forlorn man seated at it. This startling yet heartbreaking vision faded out of sight, leaving the stunned employee thoroughly shaken.

The branch manager of the bank has worked there for well over twenty years. She graciously shared her personal experiences with me regarding the bank's resident ghost. As with the Apollo, we know that some people like to name their ghosts, and the staff decided to name theirs Jasper—for no particular reason. He's not really seen anymore, but he definitely likes to make his presence known from time to time. The sounds of disembodied footsteps will often be heard clomping up and down the back staircase. There was one occasion when the branch manager had some business cards developed for a business that had just opened an account with the bank. She had the cards sitting in the middle of her desk awaiting the arrival of the business representatives who were coming to retrieve them. She stepped out of her

office briefly, and when she walked back in, she was puzzled to see the stack of cards was gone. She immediately went out and made her rounds from one employee to the next, inquiring about the whereabouts of the missing cards. Everyone had the same answer: they had not seen the cards, they had not taken them and no one had been in her office. The representatives from the new business client arrived to pick up the business cards, and extremely embarrassed, she had to inform them that she didn't know what happened to them. For their inconvenience, she offered to have a new set of business cards made and said she would personally deliver them to the business. She delivered the new batch of cards to the business as promised and returned to the bank. Upon walking into her office, she made a shocking discovery: the first batch of business cards was sitting on the window sill of her office in a neat, orderly stack. She had checked that office from top to bottom and knew that if those cards had been there during her search, she certainly would have seen them. Perhaps someone in the office took a prank to the extreme; however, the branch manager felt her employees were not the type of individuals to engage in such conduct.

One night, the branch manager and another employee were alone in the bank after hours doing some catch-up work. The branch manager left the lobby area to go to the back to use the restroom. Upon returning to the main lobby, she found her female employee ashen white, with her eyes as big as saucers. She immediately asked the frightened woman what was wrong, and the employee responded, "Where were you at?" The confused branch manager informed her she had gone to the back of the building to visit the restroom. The woman said that a shadow had just passed through the lobby immediately before the branch manager had emerged from the back area. At that point, they both decided to lock up and go home for the night.

Another evening, the branch manager was in the bank after hours, and she had a little girl with her. It was only the two of them alone in the building. The branch manager often placed coffee and donut holes in the lobby for the enjoyment of customers when they came in to take care of their financial business. On this particular occasion, there was only one donut hole left on the platter. She told the little girl she was going to the back to retrieve the box of donut holes to add the last donut hole to it. When she returned with the box, she found the platter empty. She immediately accused the little girl: "Why did you eat that last donut hole when I told you I was going to the back to get the box to put it in?" The little girl simply looked at the flustered manager as if she were crazy and replied, "I didn't eat that last donut!"

Sometimes the employees would be at the front desk with large stacks of paper on the counter. They would turn around to tend to another task, only to turn back around and discover that the stacks of paper had been pushed all the way to the other end of the counter. They are now comfortable enough with the ghost that they address him when he does such things, admonishing, "Jasper, stop it!" Sometimes months will go by without any incidents, and then the activity will pick up considerably for a period of time. So while he may have had a sad, tragic life and a heartbreaking ending, in the afterlife, Jasper sure seems to be having fun playing tricks on and scaring the women who work at the bank!

Chapter 12
ECHOES FROM THE PAST AT BOYDVILLE

Just past the historic district of old town Martinsburg, located on the south side of the city, are the 400 and 500 blocks of South Queen Street. This area of town for generations has been known as "Tuxedo Row." It is officially listed on the National Register of Historic Places as the Boydville Historic District. This residential area is considered the affluent section of town. Military, political and business leaders who served in the federal, state and local governments lived in the elaborate, architecturally/historically significant homes that line this most splendid and impressive stretch of town. All of the houses on the west side of the 500 block of South Queen Street have spacious lawns, which add to the setting of the large, mansion-style houses for which this area is famous. The craftsmanship and intricate design of many of these towering Victorian and Georgian dwellings are a feast for the eyes as one strolls down the sidewalks in this peaceful setting.

The centerpiece of this district and the feature it is named for is the massive territory surrounding Boydville Mansion. The sweeping lawns and seemingly endless tree-lined driveway lead one to a sprawling Georgian mansion that is the manor house for this oasis of serenity and solitude. The house and the grounds are reminiscent of a plantation from the iconic southern novel *Gone with the Wind*, by Margaret Mitchell, and the beloved classic 1939 film of the same name. A feeling of nostalgia is invoked as one walks about the spacious property—a sense of and, perhaps, longing for an era long gone.

Boydville's history dates back to 1812. It was built by General Elisha Boyd, a prominent and prestigious man with an endless list of accomplishments and

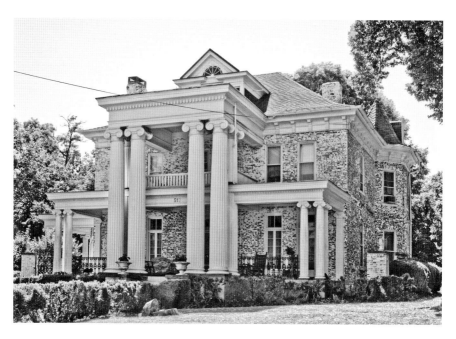

An example of the fine architecture of the homes in the Boydville Historic District. *Photo by Acroterion.*

contributions to Martinsburg's early heritage. He studied law in the office of Colonel Phillip Pendleton, one of the earliest and ablest lawyers in the early courts. Mr. Boyd was elected to the House of Delegates in 1796, and in 1798, he was chosen by the County Court of Berkeley as its attorney for the state, an office he held for the next forty years. He commanded the Fourth Regiment of the Virginia militia in 1812 in the war with Great Britain, when the cities of Norfolk and Portsmouth were threatened by a second attack of the British land and naval forces.

It was during this time that Mr. Boyd purchased the land that became Boydville from the nephew of General Adam Stephen (who shared the same name) for a grand total of $290. On this land, he built the historic gem so beloved by the community today. His personal life included three marriages, all of which, sadly, ended in the untimely deaths of his wives. He had five children, and his daughter, Mary Boyd, inherited the Boydville estate upon her father's death. In 1833, she married Charles James Faulkner, another highly successful lawyer and politician in the county. His journey to the success he later found had humble and tragic beginnings, with the death of his parents leaving him an orphan to be reared by strangers. Not allowing himself to be victimized by the harsh realities of what fate had so cruelly

dealt him, he forged ahead, attending law school and obtaining a leading position on the bar and in the politics of his native country.

He secured a large majority for votes at the polls of Berkeley County in favor of the Constitution when the people of Virginia were to decide whether the Constitution of 1830 should be the fundamental law of the state. In 1832, Mr. Faulkner was elected to the Virginia House of Delegates, and he submitted to the legislature and advocated a proposition for the abolition of slavery. He was elected to Congress in 1851, a position he held for four consecutive terms, and was appointed minister to France by President James Buchanan in 1859. When he returned to the United States after the start of the Civil War, he was arrested and charged with negotiating arms sales for the Confederacy. He was paroled in December 1861 and arranged to be exchanged for Congressman Alfred Ely of New York, who was taken prisoner at Bull Run. He then joined the Confederate army and was appointed by General Thomas "Stonewall" Jackson to his chief of staff, with the rank of lieutenant colonel. After the war ended, Mr. Faulkner returned to Berkeley County, to the new state of West Virginia. He continued to practice law, and in January 1872, he was a member of the Constitutional Convention of West Virginia. In 1874, he was elected to the House of Representatives. Charles James Faulkner died on November 1, 1884, at his residence of Boydville.

Mr. Faulkner's son Charles James Faulkner Jr. was the eighth and last child of Charles and Mary Faulkner. Like Elisha Boyd and his father, Charles James Faulkner carried on the family legacy, becoming a lawyer after military service for the Confederate army in the Civil War, where he served as aide to General John Breckenridge and

Charles James Faulkner, a highly successful lawyer and politician in Martinsburg, married Elisha Boyd's daughter, Mary Boyd. *Library of Congress Prints and Photographs Division.*

then to General Henry Wise. He went on to become a judge and then became a United States senator in 1887; he served two terms. He inherited Boydville from his father, and he willed it to his son and namesake, Charles James Faulkner III.

Charles James Faulkner III was born in August 1887. He graduated from Washington and Lee University and was an attorney at law, again following in the footsteps of his father, grandfather and great-grandfather. He became the next and last owner from the Faulkner family of Boydville in 1929, at the death of his father. He was known as Jim and was the general counsel for Armour and Co. in Chicago. He returned to Boydville as often as possible and eventually retired there. His sister, Sallie Faulkner Snodgress, lived in the house until he retired. He died there on September 3, 1953. His wife, Elizabeth, lived there until her death in March 1956.

The house was sold to May and Roderick Cheeseman in 1958, and during their tenure, it was listed on the National Register of Historic Places. They sold the property in 1987, and in the early 1990s, the property was sold again and became a bed-and-breakfast. In the early 2000s, it was acquired by the Berkeley County Farmland Protection Board, which maintained it until it was sold again. Today, it is a popular destination for weddings, and there are plans to once again make it a bed-and-breakfast.

I've discussed the family's long, rich history; their importance and contributions to the town's historical legacy; and their cherished 1812 landmark, which is still with us today. However, it needs to be understood that despite the family's prominence and prestige, they also suffered their fair share of personal tragedies and heartaches, which played out within the walls of the ancestral home. Some believe that the house, and the land it occupies, still holds memories and spiritual reminders of some of the happy, and not so happy, events that have unfolded here throughout the ages.

Legend has it that Elisha Boyd had a young grandson whom he absolutely adored and cherished more than anything in this world. In a harsh stroke of fate, the jubilant, radiant child suddenly became stricken with an illness and became very, very sick. Mr. Boyd, in an outward showing of his adoration for his beloved grandson, allowed him to reside in his bedroom and added the full use of his own large bed in the hopes that it would give him some extra comfort for his ailing, frail little body. A doctor was called to the house, but despite his best efforts, there was nothing that could be done to bring the poor child back to health. In a devastating, heart-shattering moment, Mr. Boyd's beloved grandson died in that very room, on his grandfather's bed. Another version of this story states that the child was the grandson of a doctor who was staying at the house. The child became ill, and the

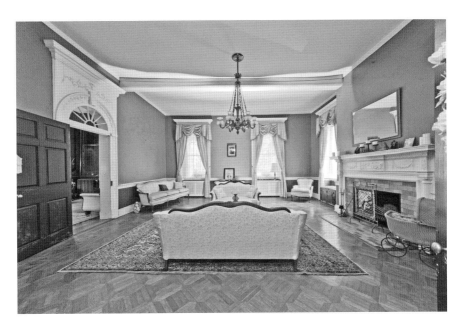

One of two parlors found inside the Boydville mansion. *Photo by Swadley Studio.*

doctor did all he could to save his grandchild, but his efforts were in vain. His grandson passed away. Out of grief, the doctor died shortly thereafter in the same room where his grandson had taken his last breath. In the early '90s, when the house was converted into an inn, that bedroom, which is known as the Elisha Boyd Room, had the original bed where Mr. Boyd had slept and where the unfortunate tragedy involving the child is said to have happened.

The innkeeper began having guests come to her to tell of strange experiences they were having while staying in that particular room. One woman came down one morning with her husband and announced to the innkeeper, "Lady, I don't know what kind of ghosts you've got here!" She then went on to tell her about what had transpired the previous night. The woman had fallen asleep on her stomach, as she always did. During the night, it felt as if someone were lying on her arm. She thought it was her husband, but when she turned over, she realized he was on the opposite side of her. The woman, dazed from the abrupt awakening to an otherwise peaceful slumber, then realized that someone was holding her wrist as if checking her pulse. She looked up and saw a man standing by the bed. By the manner in which the man was dressed, he appeared to be a doctor. Another couple was housed in the spacious bedchamber. This woman's husband had a snoring problem, and he was making it quite difficult for her to comfortably settle

into REM sleep. She got out of bed and moved to a smaller bed located on the other side of the room. She awoke during the night to something holding her firmly down on the bed. Hands were pinning her shoulders to the mattress, rendering her immobile. She thought her husband was getting amorous with her until she realized he was fast asleep in the bed on the other side of the room.

Another woman was housed in the room during her overnight stay at the inn. She, too, had fallen asleep on her stomach. During the night, she was awakened by the physical sensation of heavy pressure on her back. The pressure was being applied by two hands pushing down on her back, and it felt as if the air were being pressed out of her. In that frightening moment, her body became immobile, frozen, with no ability to defend or remove herself from the aggressive force of unknown origin. After those few terrifying moments passed, the woman's physical mobility returned, but suddenly the room seemed to plummet in temperature, becoming several degrees colder. The sound of footsteps pierced the silence and became fainter as they traveled across the room away from the bed. What sounded like the faint laugh of a child followed the steps in the cold darkness that blanketed the room. The unnerved woman reluctantly told the innkeeper of her experience the following morning, afraid the proprietor might question her mental state. She was surprised to discover that the reaction she got was quite the opposite; the innkeeper had heard several other female guests tell her of having similar experiences and nocturnal visitations from an unseen visitor in that bedroom. Strangely, it was only women who ever reported these disturbances.

One of the most impressive rooms in the house is known as the Mural Room. This is a quite large room and bears the name for an impressive mural that covers an entire wall. It was put in by the Cheesemans during their ownership of the mansion. The scene depicted is of the historic Hudson River Valley and is only one part of a much larger mural. Jackie Kennedy Onassis reportedly had the same mural, in its entirety, completely encompassing the walls of the President's Room of the White House. Guests who stayed in this room overnight would approach the innkeeper, asking who was responsible for the beautiful singing they heard directly above the room on the second floor. They would say it sounded like a woman with a melodious voice singing or humming a lullaby as one would to a child. When this was reported by guests, there was never anyone staying in the room directly overhead, a small bedroom known as the Mary Boyd room. Formerly, the Mary Boyd Room had been the nursery. The innkeeper was

never surprised at the reports of the ghostly singing, for she herself had heard it the first night she stayed in the house.

Tragedy struck the Faulkners in the cruelest of ways when Charles James Faulkner Jr. lived in the house with his wife, Sallie Wynn. In 1891, she became stricken with a debilitating illness, and after weeks of being confined to her bed, she died with her heartbroken husband right by her side. She was only forty-four years old; however, this was just one tragic death in a trilogy of unexpected deaths involving Sallie's siblings. Ten years earlier, her sister Elizabeth Garrett Winn had been fatally struck down by illness at the age of forty. She was a schoolteacher, lived with the Faulkners and died in the house. Sallie and Elizabeth's other sister, Eleanor Watson Winn, who also lived with the family, became ill and also died tragically in the house at the age of forty-eight. After Sallie Winn's death, her sister Eleanor took over the care of the children until her own tragic demise. It's anyone's guess who is behind the haunting vocal melodies. Perhaps it's Eleanor Watson Winn, still consoling and comforting her sister's children in their sorrow after the devastating passing of their mother. Or perhaps it's one of the other mistresses of the house, still nurturing and loving their children as they had done in life. To those who have heard the ghostly singing, the disembodied vocals are anything but frightening.

Another spectral visitor to the home had a more personal connection to the innkeeper. Often, when she was in the kitchen, she would look out the kitchen window and would see an African American man walking across the vast lawn of the property. He seemed to be wearing what appeared to be old, tattered-looking clothes. When the appearances of the strange man first began, she actually walked out of the kitchen door to where she had seen him, thinking someone was trespassing on the property. However, her investigation always ended the same—with vast, empty, landscaped lawns and no one in sight. The innkeeper's business partner named the man Henry due to the frequent sightings.

The innkeeper said that what was interesting about Henry was that he seemed to appear to her only when she was upset or worried about the house. During these emotional times, seeing Henry gave her inner peace and a feeling of comfort, as if he were being shown to her as reassurance that everything would be fine and the spirit was watching over her and the property. During her ownership of the house, a series of "coincidences" made her attribute more tangible behavior to the spirit beyond his appearances. She recounted to me that she would think of something she needed that she didn't have or that was misplaced. She would walk into another room, and

the missing or needed object would be placed in the room waiting for her. She thought it easily could have been chalked up to a fluke happening or mere coincidence except for the fact that it occurred more than fifty times in her years there. She said she always felt that it was Henry who did these kind deeds for her. Again, she felt this spirit was protective of her and the home and was there to help her.

One afternoon, a young woman was on her way to the property to visit her boyfriend, who lived with his parents in the cottage located behind the main house. As she was walking across the back of the lot in the direction of the dwelling, she was approached by an African American man. He was wearing rough, weather-worn clothing and nervously asked her, "Could you tell me where the Boydville House is?" A bit taken aback by the sudden, unexpected appearance of the man, she pointed him in the direction of the manor house, and the man said, "Thank you." As she turned around and continued in the direction of her destination, she looked back, and the strange, lost man she had just spoken with was nowhere to be seen. Henry's identity has never been uncovered, but Boydville was a working plantation, and there were slaves, farmers and laborers who worked the grounds and handled the upkeep of the property. It's believed that Henry was one of those people.

Mary Faulkner, Charles James Faulkner's wife and daughter of Elisha Boyd, is the heroine of one of the most memorable stories from Boydville's long and rich history. Union general Martindale of the First New York Calvary arrived at the front door of Boydville and informed Mary that he had been given orders from General David S. Hunter to burn the house down in retaliation for the Confederate burning of Governor Bradford's home in Maryland. The officer informed Mary that she and her daughters had one hour to gather their belongings and vacate the home before it would be burned to the ground. Mary, with much love and sentiment for her home and all the cherished memories it held for her and her family, was not about to part with the house without a fight. She quickly wrote a telegram to President Abraham Lincoln with a desperate plea that the house be saved from the torch. A messenger galloped to the town, and the message was instantly flashed to Washington. Mary watched in agonizing anticipation for the messenger's return as the clock ticked down to the final moments when the awaiting soldiers on the lawn would carry out their ordered devastation on the house. Suddenly, a messenger came galloping down the nearly quarter-mile driveway, waving a paper in his hand. When the horse came to a halt, he bolted off the saddle and rushed to the front door. He handed the

telegram to the anguished Mary, and she immediately tore it open to see the kind words of President Lincoln giving the clear and concise order that the Boydville Mansion was exempt from burning. Mary informed the awaiting executioners of the house, and they tipped their hats and galloped back down the dusty road to their camp. Had it not been for Mary's valiant efforts and quick thinking, the house would not be standing today.

In addition to the manor house almost being torched, the property itself was utilized by both Union and Confederate forces throughout the war. Encampments from both sides tarnished the pristine landscaping of the plantation with the brutal realities of war raging all around. Many of the other buildings and sheds were used as makeshift field hospitals for the wounded and dying. Some people today say that at night, a soldier can be seen walking about the grounds carrying a lit lantern in his hand. No one has ever reported for which side the soldier fought. The innkeeper said she had at least seven different guests report seeing him. Her business partner said that on one foggy night, he looked out a window and saw a light meandering through the fog-enshrouded grounds. He never ventured out for further inspection; rather, he chose to stay in the safety of the house and observe. Legend says that the phantom light–bearing soldier is one of the sick or injured soldiers whose life's blood seeped away on the property during the war. Perhaps he continues to walk the grounds, checking on his fellow sick and injured comrades as he did in life—before he joined the ranks of the other men who tragically lost their lives.

The cottage located in back of the manor house is believed to have once been a one-room schoolhouse. When a family was renting the cottage, they had many unusual incidents. Objects would get moved around when nobody had touched or rearranged them. The woman's hair would get touched by invisible hands. Things would come up missing and then turn up in really strange places, like the inside of her car. One morning, she walked into the bathroom and saw a bottle of fingernail polish actually tipping on its side as if something were holding it there. It was suspended at a strange angle. In awe of what was happening right before her very eyes, she called for her teenage son to come and look so she had a witness. It was like some weird gravity was suspending it at the side of the sink area—an image she said she has never been able to erase from her memory.

She used to keep a bunch of dried flowers on a table in a vase. One morning, her son got up for breakfast to find that all of the blue flowers had been pulled out of the bunch and were laid neatly around the vase on the table. Her son yelled for his parents to see what appeared to be a childish

prank of sorts. He was extremely upset by the inexplicable incident, not finding it amusing. He never liked living in the cottage because of these strange events that happened on a regular basis.

So why are all these "unnatural" experiences reported here so frequently? The innkeeper told me that during her tenure at the house, she spent a lot of time alone yet she never felt like she was alone in the house. It was never a feeling of being menaced or an unsettling feeling; rather, she said there was something almost magical about the large, history-laden home and the sprawling grounds that seem to almost endlessly surround it. It was very much loved by its former occupants; many lives began and ended here, and personal triumphs and tragic pain were felt by many within its ancient walls. Yet through it all, the house has majestically stood, in spite of the challenges faced and the sometimes tragic departures of its inhabitants. Perhaps some people weren't ready to leave the house when their lives were so suddenly and prematurely extinguished. Perhaps they can't let go of what they left behind or what was taken from them when their times came, and they continue to return to the place they loved, refusing to leave and ignoring the absence of their earthly embodiments. Or perhaps it's just images and memories forever stamped on the environment, an "imprint haunting," and only certain people are able to see or sense them. But one thing is for sure: the house has stood since 1812 and thankfully is still with us today, a proud tribute to Martinsburg's history and heritage.

Chapter 13

THE LADY IN BLACK AND OTHER SPIRITS OF ST. JOSEPH'S CEMETERY

L ocated on South Street in the Boydville Historic District is a large cemetery on a hill surrounded by a stone wall. Within those halls can be found outstanding sculpture work and tombstones, some in pristine condition, others marred by the ravages of time and harsh weather conditions. It is St. Joseph's Catholic Cemetery, established in 1802.

From the elevated vantage point of the cemetery's location, a pleasant view of the landscape of downtown Martinsburg can be seen. The spire of the Catholic church soars high above the horizon, and the impressive dome of the courthouse can be seen. Also located on this property at some point in the 1800s was the stone building that housed the Martinsburg Academy, which Elisha Boyd helped establish. Buried within this beautiful cemetery are veterans from the Civil War, as well as Italian textile workers from the late nineteenth and early twentieth centuries. Today, the cemetery is surrounded by a high, black iron fence that wraps around the entire site, with every entrance securely locked with a padlock. Visitors to the cemetery are required to get permission from the parish office to access it. However, within the enclosed walls, shut off from the rest of the world, there are said to be visitors from another plane of existence that roam those sacred grounds.

Many years ago, when he was a young boy, a man who belonged to a well-respected family used to play in this cemetery, often with his neighborhood pals. On one particular occasion, they were sitting atop one of the stone pillars that flank the main gate of the cemetery. As they were sitting there, they noticed a woman from a distance approaching the far end of the

A panoramic view of the historic district of Martinsburg from the elevated vantage point of St. Joseph's Cemetery. *Photo by Justin Stevens.*

sidewalk that runs the full length of the cemetery's front. This woman stepped onto the sidewalk and began traveling in their direction. As they looked curiously to see who was walking toward them, they noticed the woman was short in height and dressed completely in black from head to toe. She wore a big hat with a veil that completely obscured her face and an ebony dress. She appeared to be dressed in Victorian mourning attire. She walked without making a sound, seemingly focused on her destination. When she got to the gate where the boys were perched atop the pillar, she turned and began crossing the threshold of the cemetery, passing between the two pillars marking the entrance. She was completely oblivious to the fact that these young boys were watching her. They noticed that through the black veil that flowed about her face, she appeared to be an elderly woman in her seventies. As she passed by them, the air suddenly became frigid, causing the hair on the backs of their necks to stand on end. They continued watching the mysterious woman as she headed down the main path of the cemetery. Now, at that time, there was a large maple tree that stood close to the path where it makes a left turn forming an L shape. As the massive, leaf-

filled overhanging branches from the tree began obscuring their view of the enigmatic visitor, they decided to follow her to see where she was heading. When they reached the point where the huge tree hid her from view, they realized the woman was nowhere to be found. As their disbelieving eyes traveled across the vast sea of graves and headstones, the eerie suspicion that they were completely alone in the cemetery was confirmed. The little black-clad woman had seemingly vanished from the old churchyard.

That evening at the dinner table, the bewildered young boy shared the puzzling experience with his father, a no-nonsense, renowned judge not given to wild imaginings, a man well bred on hard facts and hard evidence. As the young man reluctantly shared the details of the vanishing visitor, to his surprise, his father and his uncle (who was also at the table) exchanged glances, and both of their lower jaws practically dropped to the table in astonishment. His father exclaimed, "You've seen the Lady in Black!" He then went on to recount how, when he was a young boy growing up in the same area of town, he would also play and frolic in the cemetery. He would climb up into the trees that line the sidewalk in front. He went on to say that he would often see a woman of small physical stature dressed completely in black, silently walking down the sidewalk and passing through the front gate of the cemetery, then continuing down the path and fading away from sight. It was an experience he never like sharing and kept tucked away in his memory bank, not wanting to be ridiculed or accused of dishonesty. But much to the relief of his son, he shared this private memory from his childhood. The young man's uncle confirmed that he had seen the apparition as well.

The Lady in Black is one of the most famous ghosts in all of Martinsburg's haunted heritage. Stories and sightings of her never change. She always walks down the front sidewalk, passes through the main gate and walks in an L shape, following the path and disappearing before she reaches the grave site she is visiting. It is said that she was seen frequently in the 1920s and 1930s, and many important, credible witnesses have been subject to the woman's ghostly visitations. Business leaders, members of the Catholic Church and even a former mayor are all said to have had encounters with the famous spirit. Who exactly this woman is and to whose grave she continuously comes to pay her respects is as enshrouded in mystery as the flowing black veil that hides her face from view. Today, the cemetery is kept perpetually locked, but it doesn't seem to have prevented the specter from entering. People are shocked when they see a short woman in black walking through the cemetery beyond the locked gates, fearing that someone has broken in, until they realize all gates remain securely locked. An interesting

The path where the legendary Lady in Black is said to walk. *Photo by Justin Stevens.*

aspect of these reported sightings is that she is never seen at night. She has been seen in the morning, in the rain and around dusk but never in the nighttime hours; however, there are plenty of other spirits said to be active in her absence in the dark of the night.

One particularly intriguing tale tells of a headstone that is said to no longer be in the cemetery. A woman and her husband lived on Raleigh Street, not far from the cemetery, many years ago. This woman was going around town telling everyone that her husband was trying to dispose of her by slowly poisoning her to death with arsenic. Nobody in town believed her; they all thought she was of dubious mental capacity. Out of frustration at people's disbelief, she declared that when she died, something was going to happen. There was going to be a sign, and they would all know she was telling the truth. Shortly thereafter, the woman died and was buried in the cemetery. Not long after the burial, all of the writing on the headstone—the inscription and the name—completely vanished from the face of the stone. Not long after that, the seemingly bewitched headstone completely vanished from the grave. Years later, after the woman's husband died, the house was being cleaned out of all its owner's belongings. Down in the cellar of the house,

the missing headstone of the man's wife was discovered. Locals believed that when the bizarre defacing of the woman's headstone occurred, her husband had become afraid that people might start believing the story she was telling about him poisoning her to death and might decide to investigate further and reveal his guilt. To prevent further inquiry and probing, he had stolen the headstone, concealing it in the cellar, safely hidden from view. It is said that the base of the grave on which the stolen headstone rested was visible for years before it finally was covered over after sinking into the soft earth.

Another story is that long ago, a woman and her son moved to town and took up residence in a house on nearby Maple Avenue. The woman's young son was sad because they were in a strange new place, and he had no friends and no one to play with. One day, he came home suddenly very happy and announced to his mother that he had made new friends and playmates. A few days later, he came home sad and distraught and informed his mother that he and his new friends had just had a fight, and they left and wouldn't play with him any longer. The woman reassured her upset son that they would go and talk to his friends and straighten out the matter. She asked him to take her to his new friends and was alarmed when he led her to the lonely cemetery on the hill. He guided her to the right side of the cemetery, where many of the oldest graves are located. They finally stopped in front of the graves of a young brother and sister buried side by side. His mother was stunned when he told her that they were his friends.

The deceased young brother and sister are said to have died of scarlet fever long ago, but their playful, frolicking, care-free spirits have been said to dance and romp among the tombstones ever since. They say that many people have been startled to see these two children dressed in old-fashioned period clothes, seemingly unaware that their young lives abruptly came to an end hundreds of years ago. A resident on the street who lived in a house close to the cemetery was reportedly on the roof of his home doing work. He looked down at the cemetery and saw these two phantom children playing. He had a radio playing music as he was working and realized he was not the only one enjoying the tunes coming from the speakers. The two children were dancing to the beat of the music. The Catholic explanation that has been offered by some of that faith for why these two children remain behind in the cemetery is that they are still waiting to see the Virgin Mary.

On the opposite side of the cemetery, in the corner, is said to be the grave of a Confederate soldier from the Civil War. His spirit is said to guard the cemetery and protect it from desecration and vandals. Obviously, with the cemetery securely locked at all times, this does not occur, but prior to the

addition of the black iron fence segregating it from the public, it was open day and night, and vandalism did occur. Sightings of the soldier dressed in his Confederate uniform with a sword by his side were reported only when tombstones had just been toppled over or damage was inflicted to the historic site. It's said that he can be rather aggressive if he feels the cemetery is being disrespected or someone is doing something he shouldn't be doing. It was reported that a man walked into the cemetery one night and stood in the back corner to use that particular area as a restroom. The Confederate soldier rose up out of the ground and struck him in the forehead with the butt of his rifle, knocking him unconscious. It could very well be that this person was already full of spirits of another kind when this occurred, but that's how the story goes!

Chapter 14
SOMETHING IN THE SHADOWS AT OLD NORBOURNE CEMETERY

L ocated directly across the street from St. Joseph's Catholic Cemetery is Old Norbourne Cemetery, the oldest cemetery in the city of Martinsburg. The cemetery belongs to Trinity Episcopal Church, which was part of Norbourne Parish. The dominant religious influence prior to the American Revolution was the Anglican Church, the Church of England. By an act of the assembly in the year 1769, Norbourne Parish and Berkeley County were taken from Frederick. The original parish included all the territory now embraced by the counties of Jefferson and Berkeley and contained within its limits three churches. The first Episcopal church in the valley was built in Bunker Hill by Morgan Morgan around the year 1740. A short time before the parish was formed, a chapel was erected in Hedgesville. Another was erected in Shepherdstown and built by Van Swearingen. The original parish included these three churches. The first Episcopal church in Martinsburg was built at about the close of the Revolution and was erected by Phillip Pendleton, Esq. The original 1779 map of the town shows the English Church, as it was also known, as being located at the southwest corner of Lot 108, which is part of Old Norbourne Cemetery. The land on which the cemetery sits was donated to the Episcopal Church by General Adam Stephen and was established by law in 1778. Upon the formation of Jefferson County, which was taken from Berkeley, that territory was cut off from Norbourne Parish. The old English Church became unsafe for use, and in 1835, the decision was made to tear down the old structure and build a new place of worship. A

lot was donated, and about 1838 or 1839, the present structure on West King Street was commenced.

The old cemetery contains the final resting places of many of the city's ancestors, and there is at least one member of every important family from Martinsburg's early history interred in these hallowed grounds. The Faulkner family of Boydville and Elisha Boyd have their own private burial plot located at the center of the back wall, on the edge of the Boydville property. General Adam's Stephen's daughter Ann Stephen Hunter is memorialized here as well. Military veterans from the American Revolution, the War of 1812, the Civil War and World Wars I and II are all buried in this historic and ancient burial ground. The cemetery is surrounded by a stone wall, and the various monuments and tombstones—of varying age and decay, some fallen, some standing—litter the landscape of the cemetery. Beside the cemetery, there is a small lane that leads back to a modest, two-story white house that sits directly behind the cemetery in the far corner. The small, quaint cottage is known as the "Law Office" and is part of the Boydville property behind the cemetery. It was built in 1852 for Charles James Faulkner and used as his personal library, where his extensive law books were stored and his private business affairs and law practices were conducted in his own personal space, away from the hustle and bustle of the mansion and plantation. The house, with attractive pillars flanking the front porch, has a twelve-foot-high ceiling in the downstairs area with a fireplace. Upstairs, bookshelves line the walls where Mr. Faulkner's extensive law books and case files occupied the space so long ago. The two upstairs windows look out over the crumbling cemetery.

At night, when the moon casts shadows of the gravestones across the grounds and all is uncomfortably silent, it becomes a truly eerie place. If one let one's imagination run wild, it would not be hard to conjure up images of forms moving in the thick, black shadows and something darting in the corner of one's eye. According to local lore, however, these types of things happen—and much more—and none of it is just imagination. This place has long had a reputation for being extremely haunted, and if you ask people in Martinsburg what is the scariest place in town, many would direct you to this cemetery. Rumor has it that a sacred Indian burial mound was once located at this spot and that it was desecrated for the establishment of this cemetery. Though impossible to prove, some theorize that the property has been forever cursed as a result of the desecration, and some of the strange things that happen here are caused by the curse. The legends and tales of weird occurrences at this location seem to be endless, and many have different

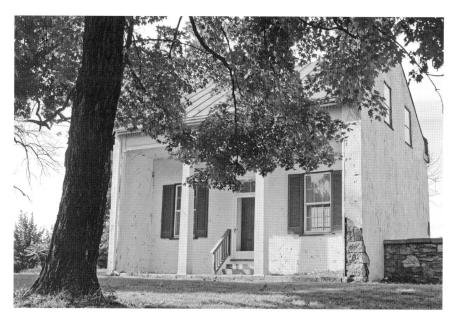

The law office of Boydville, located next to Old Norbourne Cemetery. *Photo by Swadley Studio.*

Old Norbourne Cemetery, the oldest cemetery in Martinsburg, contains many of the city's ancestor's. *Photo by Justin Stevens.*

variations and versions that have been passed down from generations past with varying details. Aside from the Apollo Theater, there are probably more haunted tales about this cemetery than any other location in Martinsburg. I'd like to share some of these stories with you.

One legend has its roots in the tragic influenza epidemic of 1918. It says that when people in the town were dying in such rapid succession, the gravediggers of the cemeteries could not keep up with the burials. They began stacking the corpses up in the back of the cemetery until a proper burial could be given. One man in the town, stricken with the illness, knew he was going to die. Since his family was poor, they would not be able to afford a funeral. He decided if he went to the cemetery and died where all the corpses were awaiting burial, surely they would have to bury him with the others, thereby saving his family the expense of having him interred. He went to the cemetery and situated himself among his fellow flu epidemic casualties but had a change of heart. He decided, expense or not, this was not where he wanted to take his last breath. He began heading for the main gate of the cemetery to exit, but upon reaching the entrance, the deadly virus claimed his weak, frail body, and he dropped dead. Some people say when they're walking past the cemetery, they hear a strained, laboring voice crying for help coming from the back of the cemetery. They look in the direction of the cries and see a sick, severe-looking man reaching out in their direction, seemingly unable to move from the earth where he lies. They think he's a homeless man who is sick and needs help, so they go to his aid. They help him off of the ground and escort him across the cemetery. Upon reaching the main gate, however, the man vanishes right before their eyes. It seems this poor man is doomed for eternity to continuously try to escape both his fate and this cemetery.

Next, we move on to the grave of a woman by the name of Sarah Pendleton Dandridge Hughes, whose story has a particularly sad and tragic narrative. She was born at the Bower in Jefferson County, West Virginia. Her father entertained Major General J.E.B. Stuart on his land many times. Stuart and his men frequently used the Bower as winter headquarters. On one of those occasions in September 1862, Sarah was engaged to John Pelham. General Robert E. Lee anointed him "the Gallant Pelham" for his heroics on the battlefield during the War Between the States. Pelham was the commander of artillery for Major General J.E.B. Stuart and was known as the boy genius of artillery. Sally, as Sarah was called, was devastated, and her dreams shattered into a million little pieces, when her beau was killed on March 17, 1863. She later married a young lawyer, Blackburn Hughes,

in the late 1870s, and they lived at a home in Martinsburg. Just when she thought that happiness, which had previously eluded her, could be fully embraced, tragedy struck again. She delivered several stillborn children and then herself succumbed to death during childbirth at the age of forty on September 2, 1879. Her last child died during birth as well. She lived for only seventeen years after John Pelham died.

Sally's grave is a concrete slab vault that lies horizontally on the ground. Due to exposure to the elements and age, a large crack has formed directly across the center of the lid, separating it into two halves. A strange thing is said to happen at Sally's grave: the lid has been known to open on its own. A woman who has spent a lot of time visiting at the cemetery told me that on one occasion she noticed that where the lid of the vault has split in two, both halves were pushed apart so that the slab was wide open. She walked over and pushed the fractured halves of the lid back together. As she turned around and started to walk away, she heard the loud sound of concrete scraping and turned back around to see that the two halves were once again pushed apart. She walked back over and again closed the wide-open gap by securing the lid pieces shut. As she began to walk away, she again heard the sound of concrete scraping. Already knowing what her eyes were going to see, she turned to see that the lid had defiantly opened yet again. This time, she decided that someone obviously wanted the lid open and that it was futile to shut it a third time.

Sally lived a short life filled with much grief and heartbreaking tragedy—a lot for a young woman to bear. Perhaps she finds it humorous to "startle" unsuspecting visitors by opening the lid of her grave. Perhaps she derives pleasure from this small act, an emotion her own life seemed to have been devoid of.

Buried in a grave in the Faulkner family plot is a young girl by the name of Anne Holmes Faulkner. She was the daughter of Judge Elisha Boyd Faulkner and Susan Campbell. She was the granddaughter of Charles James Faulkner. She died of gastric fever (aka typhoid) in 1883 at eleven years of age. Her family was residing at Boydville at the time of her tragic demise. The obituary for this child was quite lengthy and clearly stated that many were profoundly sad and mourned her loss, missing her bright, radiant energy. One of Anne's favorite things was romping and playing on the lush grounds of the Boydville estate with her friends. Perhaps that's why, today, people report seeing a young girl wearing a pretty, nineteenth-century-style dress. She dances, runs and plays on the vast lawns of Boydville and near the cemetery. Some have reported seeing her running and hiding in the bushes

The grave of Sarah Pendleton Dandridge Hughes. *Photo by Justin Stevens.*

surrounding the Faulkner family plot. Others have seen her standing by a tree in the cemetery clutching a stuffed bear in her hand.

A group of female ghost hunters visited the cemetery one night. One of the investigators noticed that her friends were looking at her with faces of amazement. They told her to turn around because there was a little girl standing behind her with a bright, ethereal glow. The stunned woman turned around, but as she did, she saw the phantom child zip away behind one of the other women. As the others screamed for her to turn around, the child quickly darted behind another investigator as if she were engaging them in a playful children's game. Sightings and encounters with little Anne Holmes Faulkner are touching and heartbreaking reminders of an innocent young life so suddenly and cruelly snuffed out. Her joyful and inspiring energy, however, still persists in spirit.

Down at the far end of the cemetery, tucked back in a corner with no light and with large trees lining the back, is the creepiest part of the cemetery. The darkness and the shadows create an ominous sense of dread. Indeed, it is this area of the cemetery where few will tread—and with good reason! Extreme feelings of nausea, panic attack–like symptoms and overwhelming,

all-encompassing feelings of real "fear" are commonly reported by people. According to local legend, during colonial times, prior to the cemetery's existence, a man was raping women in the town and was hanged from a large tree that was once located on the property down at this lower end of the cemetery. His spirit is very frightening; reportedly, when he is present, you can feel his evil surround you. There is a smell associated with this spirit's presence: freshly dug earth or an open grave. It permeates the cemetery when he stalks it at night. Legend says that sometimes when you look to the back of the cemetery, you can see two red eyes piercing the darkness and smell the turned-over earth. Some people claim to have seen this villainous apparition, but the reports of his appearance seem to vary. Some claim he wears a dark suit, a black cape and a top hat and that he has a long, pointed beard. He has been described as looking like Jack the Ripper. Others have described the man as looking like a young Charles Manson, with black, wavy hair and a scruffy beard, though wearing nineteenth-century attire with pants with suspenders.

The most frightening thing that this spirit is said to do is come up behind people and shove them to the ground. Some claim that the spirit has chased them out of the cemetery. One of the most frightening encounters is said to have occurred when a man from a historical research website visited Norbourne Cemetery. While he was in the far back corner in the lower end, he heard what sounded like something jump down from of one of the trees behind him, yet upon turning around, he saw nothing there. He turned back around and suddenly felt two hands shove him to land face first on the soil. The terrified man quickly gathered himself off the ground and ran across the cemetery to exit through the gate. As he was running, he heard the sound of footsteps pursuing him until he was safely through the gate and out of the cemetery.

I once visited this location with a friend and two psychic mediums to see what impressions or revelations they might have regarding the inexplicable and spine-chilling events rumored to occur at this burial ground. Along with another researcher, I was strolling through the cemetery, having just explored the lower area. My friend said she kept feeling as though she were being followed and repeatedly looked over her shoulder because the feeling was so tangible. She received a phone call, stepped out of the cemetery to take the call and then reentered. When she was within a few feet of me, she tumbled forward and landed flat on the ground with a resounding thud. As I helped her up, I asked her if she had fallen since it appeared as though she had lost her footing and perhaps tripped. She said she was pushed and could feel

the two hands on her back knock her down with tremendous force. I have talked to several people who have told me of firsthand experiences of being violently pushed down in the cemetery by unseen hands. This malicious and violent behavior has been attributed to this spirit.

One of the psychic mediums who was present during our visit to the cemetery had some startling and baffling visions of the sources and identities of the entities in the old churchyard. She was immediately drawn to the back of the cemetery, where the seemingly impenetrable darkness engulfs the trees that line the back fence. She had a very disturbing, horrifying vision. She saw what she described as a "black mass"—a flowing, black, vaporous mist covering the trees. As she looked deeper into this unsettling void, she saw eighteen to twenty women and children hanging by their necks in the trees with hoods pulled over their heads. They were all female and had met their demise by being tortured and murdered. She felt they had not all been killed by the same person or even died at the same time since their styles of clothes suggested they were from different eras throughout time. Somehow, this "entity" had collected their souls and trapped them there, not allowing them to leave. The black mass began to morph into a man, and around him she said there was rape, strangulation and a knife. She described the man as wearing a dark suit with a black cape and having a long, pointed beard. She said the man was hanged from a tree that was no longer on the property. She felt he had violated more than one woman but was hanged for only one known crime. As he was assaulting one poor unfortunate woman, he was strangling her. He didn't mean to kill her but used a little too much force and managed to choke the life out of her. He was caught, and the townspeople executed him by hanging him from a tree on the property. She felt this "male spirit" was connected to this black mass but was unsure whether he was the sole individual that embodied this dark, horrifying presence. She felt this black mass was perhaps the embodiment of the dark, negative energy of several events/individuals. She said the entity has occult knowledge. Oddly enough, a woman who lives near the cemetery once walked in there to explore. She saw a woman hanging from one of the trees, wearing a long, old-fashioned dress. The apparition vanished as she observed it. The woman knew of none of the stories or legends of this location.

The medium is not from the area and knows absolutely nothing about Martinsburg, its legends, its ghost stories or its history, but this was the vision she said she was shown during her visit. This "psychic vision" ultimately leaves more perplexing questions than answers: When did this dark entity take up residence in this cemetery and why? Who were the entrapped souls

The "dark area" of Norbourne Cemetery, where few will tread. *Photo by Justin Stevens.*

in the trees? Who killed them, when and why? How does the dark man who looks like a Jack the Ripper–type fiend fit into all of this? Other psychics and mediums have visited this location, and they have all seen different things, but one thing they agreed on in unison was that there is a very dark, malignant presence in that corner of the cemetery that some felt was very dangerous. None of them had any prior knowledge of the cemetery, the stories or the experiences, but they were all immediately drawn to, and subsequently repelled by, the same area.

I have looked into the validity of the legend of the "evil man." The supposed "hanging tree" was a huge oak tree located about a third of the way back after you enter the smaller gate down at the lower end. It was struck by lightning some thirty-plus years ago. I have never been able to locate any historical documentation of the alleged hanging, and it is possibly lost history, especially if the incident happened before the town's inception. There is no record or supporting document of any events here prior to the establishment of the cemetery. According to Thomas Kemp Cartmell's book *Shenandoah Valley Pioneers and Their Descendants: A History of Frederick County*, before Martinsburg was incorporated in 1778, there was a nameless village

here while this section was still in Old Frederick County. He also added that orders of the court defined a new road leading through a village to Stephen's Mill before Berkeley County was formed and that Adam Stephen and others had had some contention about water rights several years before. However, any substantial details of anything specific from this particular timeframe has yet to surface. It is a mystery that may never be solved.

Another piece of the legend says that the spirit of a young girl is buried within the cemetery close to the dark corner. The story goes that after being hit by a wagon, the girl's legs were so severely injured that the lower halves had to be amputated from the knees. In a desperate effort to help prevent her from bleeding to death, her father had a doctor tar the bloody stumps where the legs were severed, but to no avail. The poor child died. Her tombstone is said to glow at times, and her spirit appears as a bright white light shining through the jet black shadows engulfing the back of the cemetery. It is said that when her spirit is present, the evil spirit does not come out because she is an innocent, good and pure, thus overcoming his evil.

This historic cemetery is shrouded in mystery and spookiness, and some people refuse to visit it because of the eerie feelings they have when they are near it. One common experience people seem to have is the feeling of being watched no matter where they are standing in the cemetery. Others say they hear the sound of footsteps following behind them everywhere they walk, yet upon turning around, they see no one present. Some people claim to have seen a Civil War soldier sitting on the stone wall enclosing the cemetery. Sometimes he smokes a cigar, giving off the strong odor of cigar smoke. Cemeteries seem to be the perfect setting for such tales because of their already morbid ambiance. This cemetery, however, seems to have an even greater share of haunting tales. Whether the stories are fact or fiction, Norbourne Cemetery holds a well-deserved reputation as the scariest place in Martinsburg!

Chapter 15

THE BALTIMORE AND OHIO RAILROAD TRAIN STATION

O n May 21, 1842, the Baltimore and Ohio Railroad reached Martinsburg. The town was vitally important to the B&O because it was the largest town along the tracks between Harper's Ferry and Cumberland and provided much-needed passengers and freight (especially agricultural products) for the new line. Chartered in 1827, the Baltimore and Ohio Railroad was the first common-carrier railroad in the United States and has routinely been given the accolades of "America's first railroad" and "America's railroad university" by historians since the late nineteenth century. In 1842, the B&O erected a small depot in Martinsburg, and in 1849, William Kroeson built a hotel to cater to the passengers and railroad employees. Also in about 1849, the foundation for an engine house and machine shops was commenced. The railroad's prosperity brought wealth to the region and gave a tremendous boost to the local economy; it also provided many jobs for citizens of the town. The buildings in the train station complex were designed by the engineers of the B&O, and it is believed there was a significant influence in the design from the visionary work of Viollet-le-Duc, the pioneer French architect and theorist, as well as the work of Henri Labrouste, who was responsible for the design of the Bibliothèque Nationale de France in Paris. The Martinsburg roundhouse is the only iron-framed roundhouse still standing in the world today. On July 30, 2003, the B&O roundhouse was designated a National Historic Landmark.

Despite the success the railroad brought to the town, it also threw Martinsburg into the middle of major conflict during the Civil War. The

The historic roundhouse at the B&O Railroad Train Station in Martinsburg, the only iron-framed roundhouse still standing in the world today. *Library of Congress, Prints & Photographs Division, photograph by Carol M. Highsmith.*

B&O (and consequently Martinsburg) became a strategic target, as the railroad traversed the east–west boundary between the North and South. The original Martinsburg railroad shops, roundhouse and depot were destroyed in a "scorched earth" policy of retreat by Confederate soldiers under the command of General "Stonewall" Jackson. It was an attempt to deter the advance of Union troops into Southern territory and to prevent the Union army's defense of Washington via transportation of artillery and supplies along the railroad. During the famous raid, Jackson's troops commandeered over a dozen B&O locomotives, outfitted with "road wheels," and using horses towed them over the dirt roads into Virginia for use on the South's railroads. During the Civil War, the B&O suffered constant attacks and destruction of key wayside facilities, bridges and hundreds of miles of railroad track. One of the most devastating tragedies in all of this was the destruction of the beautiful and handsome Colonnade Bridge that spanned East Burke Street. The bridge had been given by the B&O Railroad as a special monument to the town and its people. The bridge itself was four hundred feet in length, resting on sixteen Doric columns of dressed limestone about eighteen feet high. It was destroyed by the Confederates on June 13, 1861.

The former hotel at the B&O Railroad Train Station. *Library of Congress, Prints & Photographs Division, HABS.*

Martinsburg changed hands more than fifty times throughout the war, leaving the once-thriving community a desolate wasteland, unable to feed its inhabitants, much less export anything. Following the war in 1866, the B&O began reconstruction of the roundhouse and associated shops that stand on the site today; they were completed in a span of six years, from 1866 to 1872. The train station was also the site of the Great Railroad Strike of 1877, which sparked the first national labor strike in American history.

During the summer of 1877, America was experiencing the lowest ebb of a severe economic depression. All components of the economy, however, were not sharing equally in the hard times. Great numbers of people were unemployed, and many of those who were working were trying to unite in wage cuts. Owners of industries—railroads in particular—were reaping high profits and providing their stockholders with significant dividends while reducing the wages of their employees to a level where they could not support their families. The frustrations among this country's labor force reached an explosive level in July 1877, starting with railroad workers responding to a 10

percent wage cut announced by the four major trunk lines: the Baltimore and Ohio, the Pennsylvania, the Erie and the New York Central and Hudson.

The first major response to a long list of grievances against the railroads was made by B&O workers in Martinsburg who had recently joined the newly formed Trainmen's Union. The workman called the strike on July 16, 1877. Spontaneously, and without united leadership, the strike spread to a dozen railroad centers, including Pittsburgh, Baltimore, Chicago, St. Louis and San Francisco. Within a few days, 100,000 men were on strike. Throughout much of the country, strikebreakers and militia were beaten off by mobs of individuals who had joined the striking railroad workers in numbers far exceeding the disgruntled workers. The railroad strikes were a fuse that caused other workingmen to go on strike, as they, too, were suffering from wage cuts. The throngs of sympathetic non-railroad workers combined with underprivileged masses; the hungry jobless, teenage boys from the slums; and tramps and drifters. The local strike lasted from July 16 to 19. The only documented death in the strike in Martinsburg was that of William Vandergriff, a striking railroad worker, who died on July 28 of injuries sustained on the seventeenth from a shootout with the local militia.

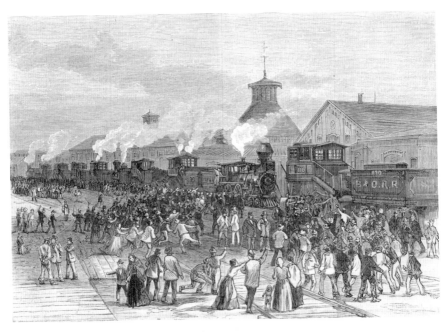

"Blockade of Engines at Martinsburg, West Virginia," an engraving on the front cover of *Harper's Weekly*, August 11, 1877. *Wikimedia Commons.*

The machine shop, where a ghostly soldier is said to walk the second floor. *Library of Congress, Prints & Photographs Division, photograph by Carol M. Highsmith.*

With so much history and such harrowing, energy-charged events unfolding at this site throughout time, not surprisingly it carries the reputation of being "haunted." In the large, rectangular, brick machine and engine shop building, people say that a Confederate soldier carrying a candle can be seen walking along the second floor. He walks the entire length of the second floor, illuminating each window as he passes by, gripping the phantom candle. Others say that on certain nights you can see what appears to be smoke rising from some of the buildings. Closer inspection of the mysterious vapors reveals no source for this puzzling phenomenon. It's almost as if the complex is still smoldering just as it must have been when the buildings were torched by the Confederates so long ago. A woman and her friend stopped into the depot that once housed the hotel to use the restrooms one night. The place was empty of travelers except for an African American man who was standing near the restroom area. He looked to be in his late forties or fifties and was wearing a dark green shirt and jeans. He looked straight at them and smiled, and in a single, shocking second, he vanished right before their eyes.

There are several distinct possibilities that could be reasons for unearthly visitors and apparitions of soldiers to return to this historic train station. As

The Baltimore and Ohio Railroad at Martinsburg. *Library of Congress, Prints & Photographs Division, HABS.*

with most railroads, there have been many unfortunate accidents and tragic deaths that have occurred on the tracks over time. Lives cut short, leaving unfinished business, and violent deaths are always said to be prime reasons for the dead to not rest and remain trapped in an earthly plane of existence. Next door, at the current site of the Union Sales Dodge Company, was a Union blockade house used to defend the railroad during the Civil War. The area surrounding the blockhouse was used as a pauper's graveyard, and several soldiers' corpses were found when the digging was done for the foundation of the present building. Today, there is a parking lot over where that pauper's graveyard was located, and there are still believed to be unknown graves of fallen soldiers beneath. Perhaps the spirits of some of the soldiers buried in those unmarked graves return, looking for the dignity and respect of being given a proper burial. Or perhaps the Civil War is still raging on in the spirit world, and the Confederate and Union troops are still burning down the buildings in the B&O complex, both still struggling to gain control of the railroad and of Martinsburg!

CITY OF THE DEAD

Located on a quiet country road at the end of East Burke Street, in the Irish Hill section of town, is Green Hill Cemetery. It has the distinction of being the oldest public cemetery in Martinsburg and is one of the most scenic, surreal and beautiful spots to be found. It was established in 1854 during a devastating cholera epidemic in the city. One local history book reports that "business was paralyzed, grass grew in the streets, deaths occurred daily, and all that could fled the town of Martinsburg for a time." On March 4, 1854, the Green Hill Cemetery Company was incorporated for purchasing and maintaining a public cemetery. Fifteen and a quarter acres of land were purchased from Ezekiel Showers for the cemetery. The cemetery is an example of what was known as the "garden cemetery," which became popular in the nineteenth century. Rather than being churchyards and morbid, somber places, these types of cemeteries had parklike settings, with beautiful gardens, fountains, benches and displays of elaborate statuary and monuments. They were places where families would hold picnics and be in a nature-type setting to reflect on and celebrate their loved ones buried on the beautifully landscaped grounds.

The cemetery's unique design was the brainchild of David Hunter Strother, whose pen name was "Porte Crayon." He made a name for himself as an artist and author that extended all over the country, and he was also a soldier in the Union army. Some of his most famous sketches printed in *Harper's Weekly* before the Civil War were drawn in Martinsburg. David Hunter Strother saw the famous cemetery Pierre La Chaise in Paris, and

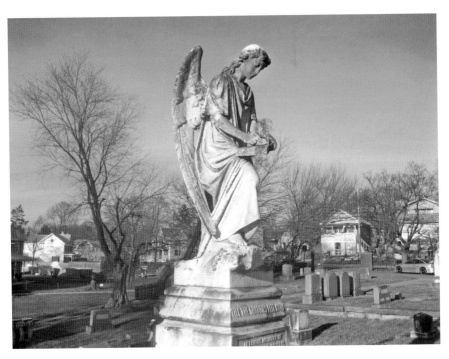

A Victorian statue at Green Hill Cemetery depicting an angel recording names in the book of life. *Photo by Justin Stevens.*

the garden cemetery motif pleased him so much that he made a sketch of it. When he returned to Martinsburg, he—along with the surveyor—laid out the grounds.

The layout of the cemetery is truly unique, with spirals wrapping around all sides of the conical-shaped hill where the cemetery is situated. At the center of the cemetery is a Neoclassical Revival stone mausoleum featuring hand-painted stained-glass windows, built in 1917–18, which replaced an earlier chapel. The cemetery is an outdoor museum of the sculptors' and stone carvers' art, dripping in Victorian opulence and symbolism. The views from anywhere in the cemetery are absolutely breathtaking, with magnificent panoramas of downtown Martinsburg and the far-reaching horizons. Among the notable burials are a famous actor from the golden age of old Hollywood, Robert Barrat, who is buried alongside his wife, Mary Dean Barrat; numerous mayors and military men, including thirty unknown Confederate soldiers, three of whom have been identified and marked with plaques; and Captain E.G. Alburtis, who commanded the company that went from Berkeley County to Harper's Ferry during the John Brown

The mausoleum replaced a former chapel and features hand-painted stained-glass windows. *Photo by Justin Stevens.*

raid and afterward fought in the Confederate army. Doctors buried in the cemetery are Florence Evers, Mary Conrad, J. McKee Sites and A.B. Eagle. Alongside the cemetery, at the eastern point, is an old, abandoned African American cemetery that is believed to have been established in the early 1800s. It is where the two lynching victims Toliver and Joseph Burns are said to be buried.

This peaceful, visually appealing hillside is also where part of the Tuscarora Indian village was said to have been located centuries ago, and there is no other place quite like it in Martinsburg. Some people feel the atmosphere is charged with a mystical, indescribable energy, and this historic spot has also had a long-running history of strange happenings and experiences. In the *Martinsburg News* column "Know Your Martinsburg," by historian Fred Voegele, he wrote, "Before the low ground east of the Supt's house at Green Hill Cemetery was drained and when it was enclosed with a high board fence, many a ghost pranced around in the shape of a 'will-of-the-wisp' causing many a passerby to wish he were somewhere else, and hastening in that direction as fast as his leaden shoes would allow him."

A former caretaker of the cemetery had a particularly startling otherworldly experience during her tenure here. Very early one cold February morning, she looked out the kitchen window of the caretaker's lodge, located on the property by the main entrance. In the winter, when all the leaves are gone from the trees that line the long driveway, the vantage point to the center of the cemetery is uninhibited. She noticed a large, blond-haired woman wearing a white dress with a print of blue flowers covering it. The dress had a white, frilly collar around the neck and frills around the sleeves. She was also wearing a canvas apron and a hat made of the same material with flowers adorning it. This woman was looking down at a particular grave site. She knelt down and appeared to be tending to the grave, pulling weeds, et cetera. As the caretaker was transfixed by this female visitor, she noticed that behind her, something else was happening. There were two regiments of Union soldiers marching across the cemetery from east to west with their rifles firmly pointed in an upward position. After about a minute, this entire ghostly vision faded from sight, and completely awestruck, the caretaker trudged through the cemetery to see whose grave the spectral woman was visiting. She discovered that it was the grave of George Newkirk Hammond, the son of Dr. Allen C. Hammond. He was a gallant Confederate soldier killed at Yellow Tavern about the same time as his commander, General J.E.B. Stuart, on May 17, 1864, at only thirty-one years of age. Ironically, the body of George Newkirk Hammond is not even interred in this cemetery. He is actually buried in the Hollywood Cemetery of Richmond, Virginia, and a memorial marker was placed in the Hammond family plot because that's where the rest of the family is buried. So who was the woman making the spectral visitation to the grave marker of the fallen soldier? Buried in the family plot is his mother, Margaret Myles Newkirk Hammond, who died on July 17, 1837. George was only four years old at the time of her death; she never lived to see her son grow up or his brave heroics, which ended with him being tragically struck down at so young an age. Perhaps she's disturbed by the fact that the memorial headstone marker for her son has now toppled over and is embedded in the soil. Maybe she wants to see her son receive the dignity and respect he deserves.

Another well-known and frequently seen apparition in this cemetery is the Woman in White. The identity of the spirit is unknown, but she is seen at the lower end of the property. She's a young woman in about her thirties with shoulder-length dark hair wearing a white nightgown, and she runs franticly among the tombstones as if she is searching for someone. Ghostly female children have also been sighted, and there is an unsubstantiated rumor that

The marker for George Newkirk Hammond, a Confederate soldier killed at Yellow Tavern, who is actually buried in Richmond, Virginia. *Photo by Justin Stevens.*

The lower portion of Green Hill Cemetery, where the Woman in White is seen. *Photo by Justin Stevens.*

during the Civil War, a group of little girls were playing at the top of the cemetery and were killed in the explosion of a cannonball that struck the hill during the fighting. One witness to these spectral children grew up near the cemetery and used to play there often as a child. She would often see a group of young girls dressed in old period dresses wearing bonnets. They would run around through the sprawling cemetery, playing and frolicking, and she would always try to catch up with them to join in the fun, but they would vanish before she could reach them. What some would consider "residual" smells associated with soldiers, such as tobacco and the putrid smell of gunpowder, also have been detected by some visitors. The cemetery is a unique historic location in Martinsburg; the stories these stones tell are a collective narrative of the town's history and the people who helped shape it. Perhaps some of them still return to visit.

Chapter 17
OTHER "SHADES" OF MARTINSBURG

M artinsburg has a few other spirits rattling around in the old buildings throughout the historic district and beyond. They aren't quite as "dramatic" and don't really have much of a narrative or background but are worth mentioning. The Christ Reformed Church on Burke Street has been the scene of "ghostly" piano playing in the old former chapel. The

North King Street, looking north from the Public Square. *Boston Public Library, Tichnor Brothers collection #73285.*

old pipe organ in the current sanctuary has been known to play a "ghostly" concerto as well. The church is rumored to be haunted by the ghost of a Confederate soldier from when the building was used as makeshift hospital during the Civil War. A house on East Burke Street was once said to have been the source of sightings of a particularly frightful apparition: an earless, legless rabbit that would crawl on its belly and disappear in the stone arch alleyway of a double-dwelling home. Old-timers tell of seeing visions from the past on South Street, in the stretch leading from the cemeteries down to the intersection of Raleigh Street. Former maple trees and cannons lining the streets from the Civil War are "passages in time." Legend also has it that the Berkeley County Courthouse is visited by the ghosts of soldiers from General Patterson's occupation of Martinsburg during the Civil War whose names are recorded in old deed book. They are said to return every year to see if that deed book is still there.

CONCLUSION

As I stated in the introduction of this book, I never realized what a rich history the town of Martinsburg had until I began research for the ghost tours of Martinsburg. Every building in the historic district area and beyond has its own unique story to tell of its former inhabitants and the events that have unfolded within its walls. Our historic cemeteries are the final resting places for those who helped shape the town and its heritage, and their stories are set in stone. The collection of stories I have shared here features many different types of haunting phenomena and spectral visitors, but there is one common thread running through each tale: they all have their roots in history and are inspired by events and people from our past.

It has been my intention with this book not to debunk or try to sway anyone's opinion regarding the existence of ghosts but rather to present the experiences of people and the reported "ghostly" events throughout Martinsburg. I also wanted to share the results of my own research and investigations and the collective result of all these various aspects. What has been presented in this book is a lot of possibility—nothing conclusive to prove or disprove the existence of ghosts or psychic phenomena but rather the potential for those things. We have looked at places with reputations for being "haunted" through legend, a historical lens, the eyes of a psychic or the eyewitness accounts of those who believed they had firsthand encounters with the "supernatural." Throughout my journey, I've certainly experienced some things that I cannot explain and encountered a lot of things that left me frustrated with a lack of answers or "definitive conclusions." I certainly

cannot dismiss the validity of the countless testimonies and sometimes astonishing accounts people have shared with me as simply being figments of the imagination. So what exactly is behind all of it? Is what these people experienced really "ghosts?" Or is it something else altogether? Certainly, something is going on, and the questions that have been raised for me, and hopefully for you as well, are the same questions that have puzzled, pondered and intrigued generations of people since the beginning of time. And there certainly does not seem to be any sign of people's interest or exploration into the subject waning anytime soon.

Regardless of your own beliefs, I hope these stories have tickled the imagination and maybe, just maybe, encouraged you to question "reality" as we know it. I sincerely hope this book will help preserve and honor these tales and legends for future generations and will continue to be passed down to keep the great tradition of storytelling alive. Ghost stories have always been a fascination for humans, and through them, there is so much to be learned about history, social views and cultural values throughout time—and, ultimately, about ourselves.

SELECTED BIBLIOGRAPHY

BOOKS

Aler, F. Vernon. *Aler's History of Martinsburg and Berkeley County, West Virginia.* Hagerstown, MD: Mail Publishing Company, 1888.

Bovey, Ethel Wayble. *Hometown Memories: Growing Up in Martinsburg, West Virginia.* Martinsburg, WV: Mountain State Publishing, 2003.

Boyd, Belle. *Belle Boyd in Camp and Prison.* London: Saunders, Otley, and Co., 1865.

Cartmell, Thomas Kemp. *Shenandoah Valley Pioneers and Their Descendants: A History of Frederick County, Virginia.* N.p.: Eddy Press Corp., 1909.

Doherty, William T. *Berkeley County, U.S.A.: A Bicentennial History of a Virginia and West Virginia County, 1772–1972, Parsons, W.Va.* N.p.: McClain Print Company, 1972.

Evans, Willis F. *History of Berkeley County, West Virginia.* Westminster, MD: Heritage Books, 2007.

Gardner, Mabel Henshaw, and Ann Henshaw Gardner. *Chronicles of Old Berkeley: A Narrative History of a Virginia County from Its Beginnings to 1926.* Durham, NC: Seaman Press, 1938.

Minghini, Lorraine, and Thomas Earl VanMetre. *History of Trinity Episcopal and Norbourne Parish: Martinsburg, Berkeley County, West Virginia, Diocese of West Virginia: 185ᵗʰ anniversary, 1771–1956*. Martinsburg, WV, 1956.

Sergent, Mary Elizabeth. *They Lie Forgotten: The United States Military Academy, 1856–1861, Together with a Class Album for the Class of May, 1861*. N.p.: Prior King Press, 1986.

Wilson, Patty A. *Haunted West Virginia*. Mechanicsburg, PA: Stackpole Books, 2007.

Articles and Documents

Barrat, Mary Dean. "History of Green Hill Cemetery." *Martinsburg Journal*, July 2, 1976.

Blaisdell, Elaine. "Preserving Over 200 Years of Church History." *Martinsburg Journal*, October 25, 2008.

Caplinger, Michael. "The Baltimore and Ohio Railroad Martinsburg Shops." National Historic Landmark Nomination Form, October 2003.

"Civil War Diaries and Letters from Berkeley County, Martinsburg, W.Va." *Berkeley Journal*, Berkeley County Historical Society (2004).

Faulkner, Jane. "Boydville and Its History." *Martinsburg Journal*, July 4, 2010.

Hammersla, Keith. "Haunted Happenings at the Adam Stephen House." Unpublished, 2014.

———. "The History of the King's Daughter's Hospital." Berkeley County Historical Society, n.d.

———. "The Oak-A Hanging Tree." *Martinsburg Journal*, April 20, 1976.

———. "Spooky Sites of Martinsburg: Legend and History." Unpublished, 1989.

Hough, Lauren. "If These Walls Could Talk . . . Historic Hotel, Elegant Past." *Martinsburg Journal*, February 5, 2007.

"Martinsburg, West Virginia During the Civil War." *Berkeley Journal*, Berkeley County Historical Society (2001).

Martinsburg Journal, May 22, 2011.

————. "Ghost Seen on Church Street." March 14, 1947.

————. "Green Hill Cemetery." National Register of Historic Places Inventory Nomination Form, n.d.

————. "Green Hill Cemetery." Statesman Industrial Edition, July 1905.

McMillion, Dave. "Black Cemetery Buried by Decades of Neglect, Trash." *Herald Mail*, May 2, 1999.

Voegele, F.B. "The Ghost Dogs of East Burke Street." *Martinsburg News*, 1939.

————. "Ghosts of Martinsburg." *Martinsburg News*, n.d.

Wood, Don C. "Belle Boyd: Spy, Actress, Local Legend."

————. "Berkeley County Jails Built with Style." Berkeley County Historical Society, n.d.

————. "History of the Berkeley County Jail." Berkeley County Historical Society, n.d.

PERSONAL INTERVIEWS

Dolores Brown, archivist/historian of the Christ Reformed Church, Martinsburg, WV.

Diane Collier, former caretaker of Green Hill Cemetery, Martinsburg, WV.

Dolly Ferguson, owner of Dolly's Bake Shopp, Martinsburg, WV.

LaRue Frye, former owner of Boydville, Martinsburg, WV.

Timothy Gasper, former employee of the Martinsburg Public Library.

Keith Hammersla, curator of the General Adam Stephen House and director of genealogy and the historical archives at Martinsburg Public Library, Martinsburg, WV.

Mark Jordan and Laura Gassler, director and executive director of Martinsburg/Berkeley County & Visitors Bureau (CVB), Belle Boyd House, Martinsburg, WV.

Sandy Kemner, former employee of the Martinsburg Public Library and former resident of Boydville.

Katie Palmer, branch manager of City National Bank, Martinsburg, WV.

Jenifer Roberts, director at the Apollo Theater, Martinsburg, WV.

David Silver, former resident of Martinsburg, WV.

Clay Smith, Spirit Watch Group, Winchester, VA.

Tricia Strader, the *Martinsburg Journal*/Belle Boyd reenactor, Martinsburg, WV.

David Wilt, property manager of the Shenandoah Hotel, Martinsburg, WV.

WEBSITES

www.findagrave.com
www.martinsburgroundhouse.com
www.orgsites.com/wv/adam-stephen

About the Author

A native and longtime resident of Martinsburg, West Virginia, Justin Stevens is an avid researcher of history, folklore and the paranormal. He is the creator and owner of the popular Haunted History and Legends Tours of Martinsburg, West Virginia, founded in 2013. His professional career has spanned a wide variety of mentoring and human resources roles, including case management, relationship management, recruiting and law firm environments. He resides in Martinsburg with his partner and their dog. Educating the community and tourists about local history and entertaining them through the related ghost stories is a purpose to which he is passionately committed.

Visit us at
www.historypress.net
...
This title is also available as an e-book